BLACKLOCK • HORIZONS

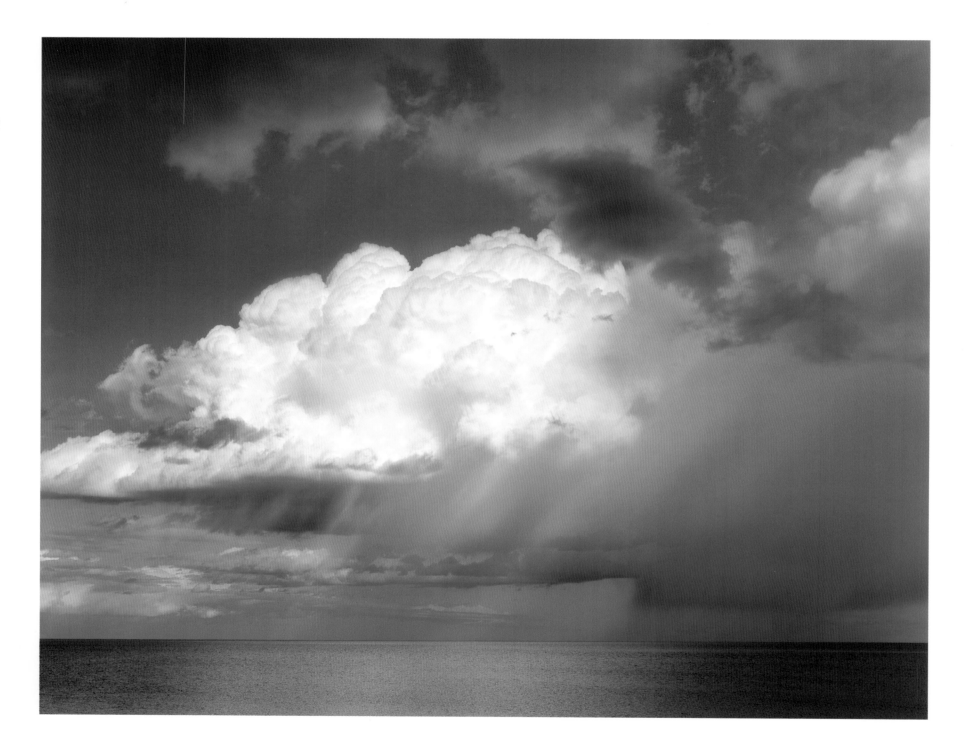

CRAIG BLACKLOCK

BLACKLOCK • HORIZONS

BLACKLOCK NATURE PHOTOGRAPHY

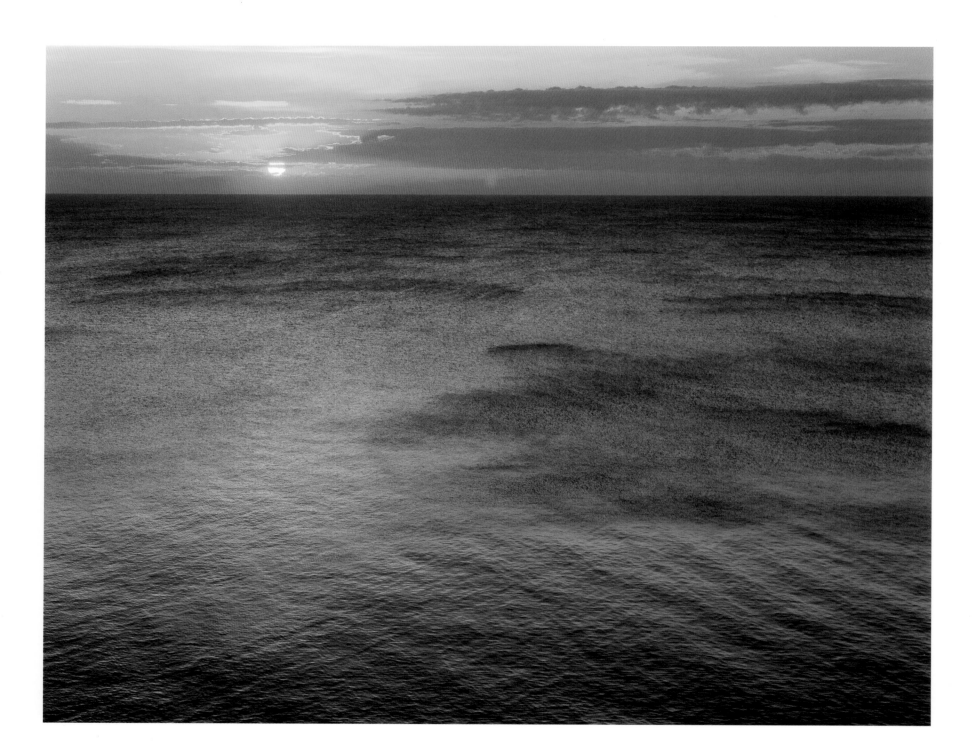

PREFACE

In our over-populated world, to gaze out at hundreds of square miles of unoccupied space, even for a few moments, allows us to catch our breath. From atop a cliff, the horizon is not an arbitrary line, but a place we can fix our eyes in wonder and awe, and dream.

My wife, Honey, and I enjoy packing what supplies we need for several weeks into our kayaks and escaping to the peace of wild shores. Some might call such trips vacations, but I have made a career of photographing the meeting places of water and land. Most often my camera is aimed along the shoreline, or towards land from my kayak on the water. After nearly twenty-five years of photographing from this perspective, I questioned what would happen if I turned the camera around. The possibility came to me several years ago, half-way through a nine-mile kayak crossing to a cluster of islands in Lake Superior. We were enjoying a quiet, calm paddle until we saw low, dark clouds and heard a heavy rain pelting the lake's surface. Four miles from the nearest land we met the windless downpour, which obliterated all signs of land from our sight. At times we could see ahead only a few feet from our boats. Then, suddenly, the clouds would shift and our view expanded to a quarter-mile. For experienced kayakers wearing Gortex drysuits these conditions were pleasant. We paddled on through water in shades of silver, pewter, and slate. Our eyes were automatically drawn to wherever the clouds seemed to meet the rain-pocked water — a fluid and shifting horizon.

The horizon has been an ever-present icon in my photography, but in most of my work I utilize multiple points-of-interest, creating complex, jig-saw-puzzle compositions. I wondered aloud to Honey what it would be like to pare down my subject matter to only sky and water. As we paddled I watched with my photographer's eye and imagined what a collection of such images might be like. The relative proportions of sky and water would alter the feelings

of weight, space, even the angle of planes. Textures within the fields, be they clouds in the sky, waves or even ice on the water would be the wind-woven canvas carrying the color gradient of the sky. During our ten day trip we discussed the possibilities and grew excited about the idea that has turned into the *Horizons* exhibition and book.

I am not the first artist to be inspired by the simplicity of the horizon line. I recalled George Morrison, whose colorful paintings of the Lake Superior horizon distill the essence of all of I have seen in my wilderness travels. This book is my tribute to his artistic legacy.

When I began working on this project I had only a few pre-conceived ideas for specific photographs I would strive for. Arising each morning in the dark, I carried my 4x5 view camera to the top of a cliff, set up and waited. The time after arriving at the cliff's edge, before making photographs, was remarkably serene. Most mornings the winds were calm and the soft lapping of waves rose from below. As the first glow appeared on the horizon the images registering on my retinas were still too dim to be recorded on film. Those will remain my private collection.

When the light did rise, so did my adrenaline level. Photographing evanescent subjects with a view camera is cumbersome, requiring a great deal of anticipation and preparation. I would analyze the situation and select an appropriate lens for what I *expected* to happen. Clouds are always on the move, sometimes very fast. In the time it took me to close the lens, put in a film holder, pull the dark slide and trip the shutter, the composition could change significantly. Like a wing-shooter allowing for the time it takes shot to travel to its target, I learned to lead the clouds, aiming my camera to where I expected they would be when I made the exposure.

In stormy or foggy weather I worked throughout the day, but on most clear days I stopped shortly after sun-up, returning again in the evening. Typically, clouds burned off

late in the day and my view to the east was of pastel pinks and blues. Night after night I exposed what I expected would be identical photographs. Yet, upon viewing the processed film, I discovered each was remarkably unique. In some the water was nearly black, in others it was salmon, or golden, or green or a wave-fragmented gradient combining all of these.

While editing the images for gallery exhibition and this book, I sequenced them emphasizing either contrasts or similarities. When contrasting colors were placed together, those colors appeared brighter. When I grouped almost-identical ones, I found myself searching out the differences — almost like viewing individual frames in time-lapse photography. In the end, I had eleven groups of images that in one way or another pleased my eye, and produced a varying rhythm to the flow of the whole.

As a child, I recall going to the Walker Art Center and the Minneapolis Institute of Arts and viewing large, modern paintings which were expansive fields of color. The subjectless paintings drew me in with the beauty of color and the subtle texture of the paint. Yet, I was stopped at the surface, frustrated that I could not identify with what I saw within the frame, as I was accustomed to in representational imagery. I find that for me, some of my horizon photographs resolved this dilemma. Implicit to the medium of photography is the understanding that what is in the image is real. *Knowing* these photographs are literal representations of sky and water allows me access into the otherwise abstract compositions. The 34x42 inch prints have the impact of scale of the modern paintings I remember and they are open to the same broad metaphorical interpretation as the paintings. This project evolved into a significant experiment in combining abstract imagery's structure, with my love and understanding of the natural world.

Once again, I have been thankful for my chosen medium and its ability to let me share what I have seen and felt.

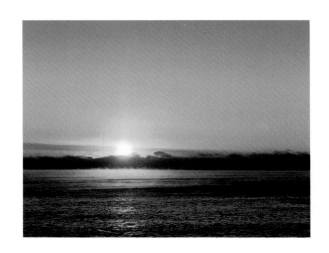 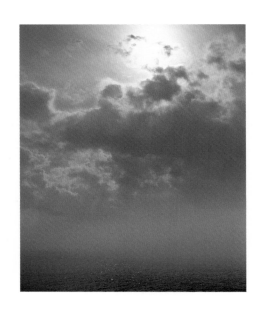 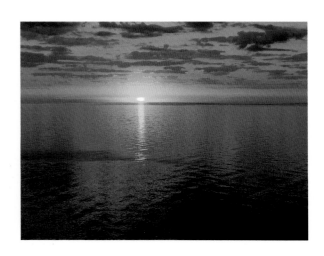

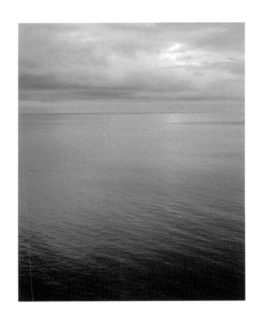
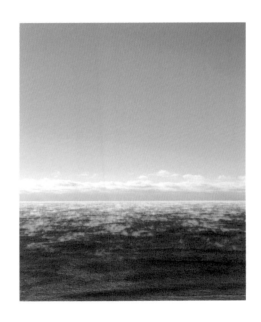
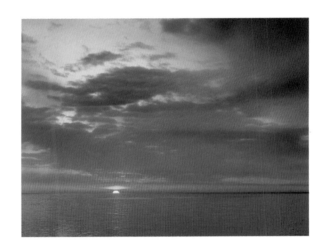

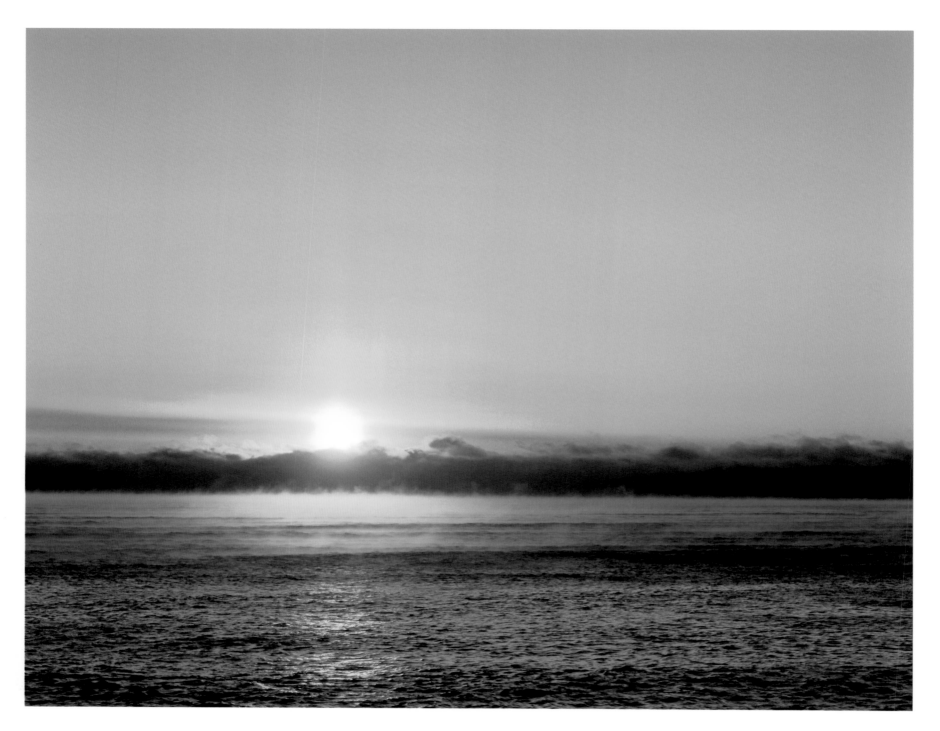

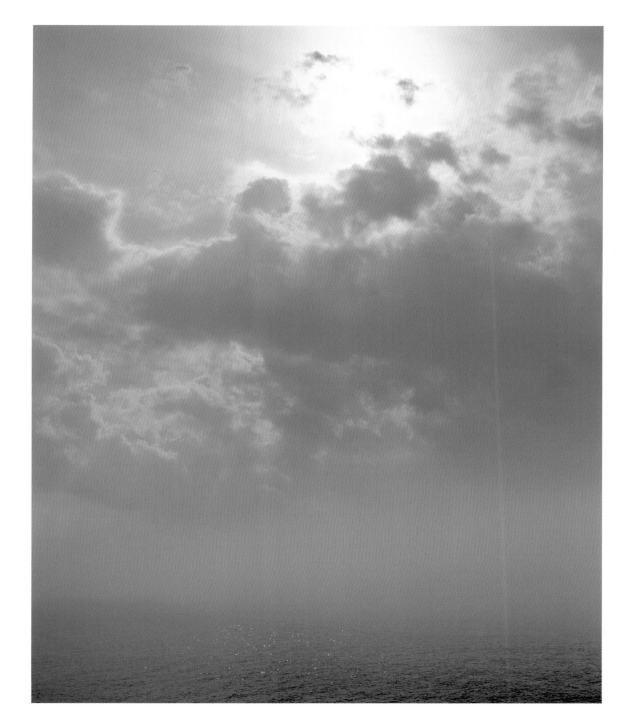

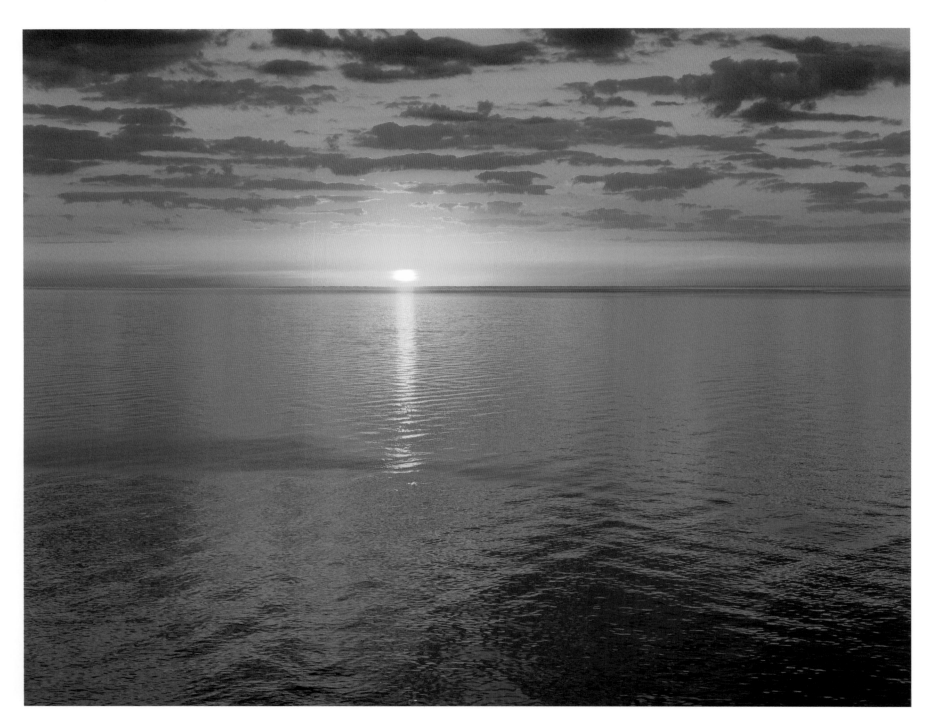

I—3

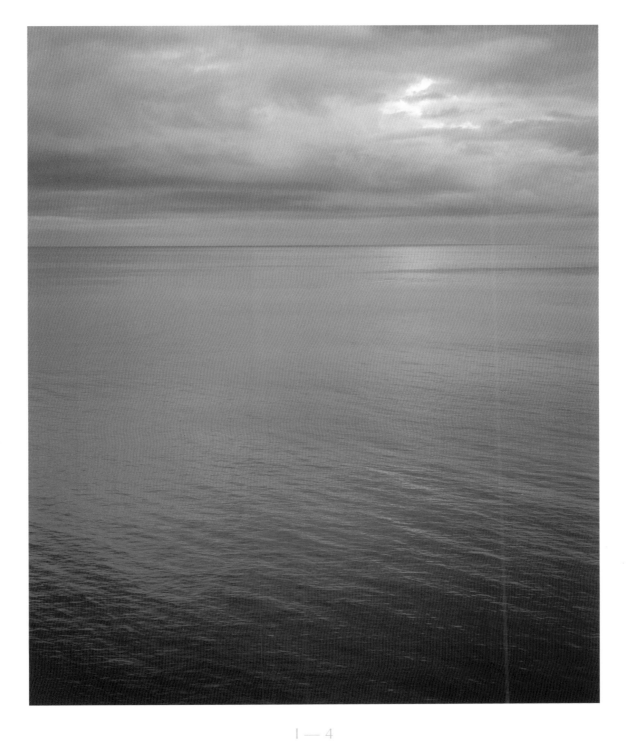

1—4

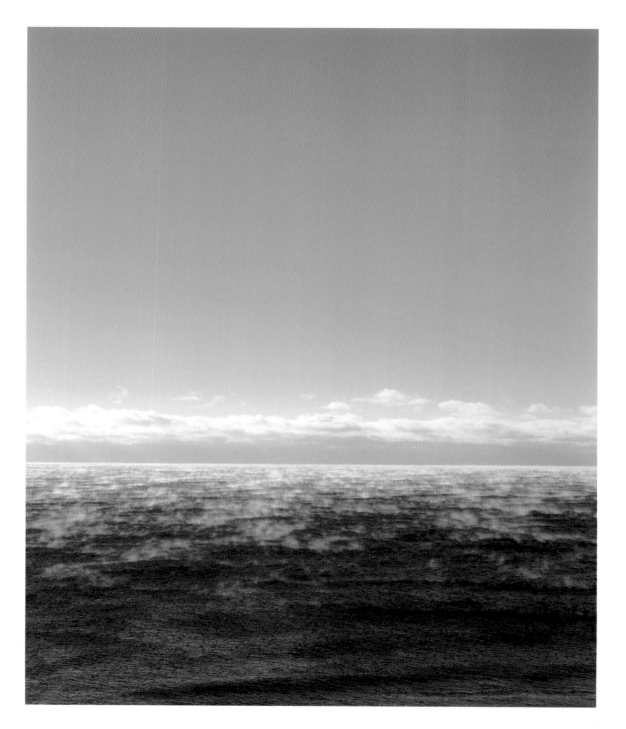

1 — 5

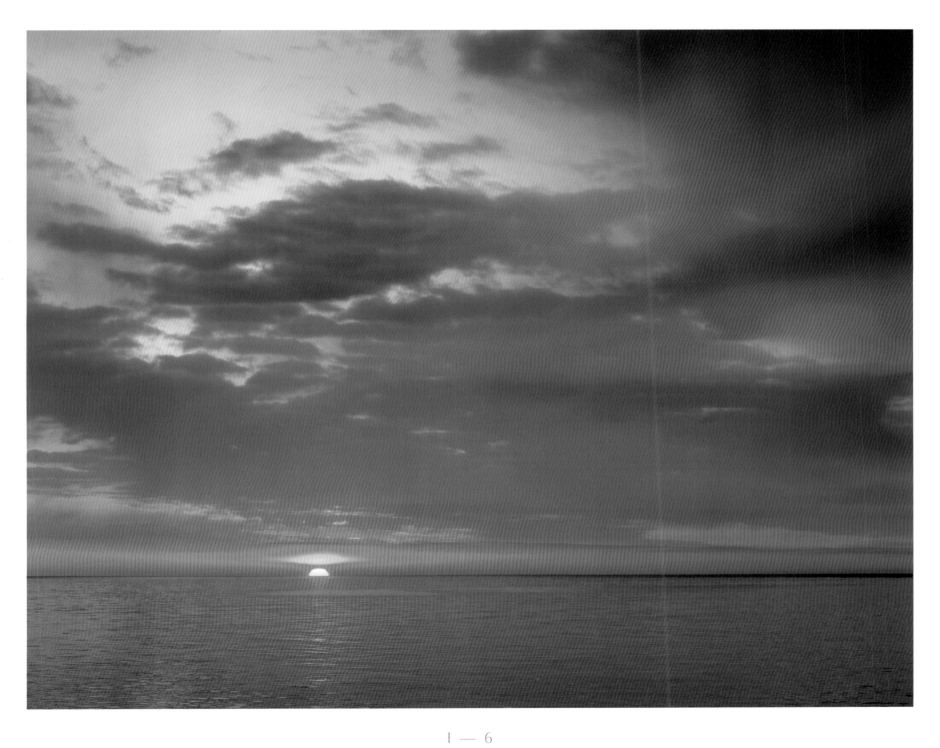

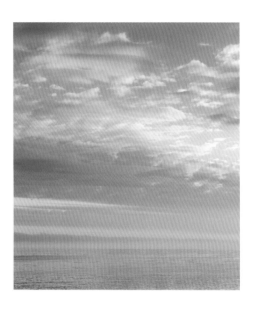
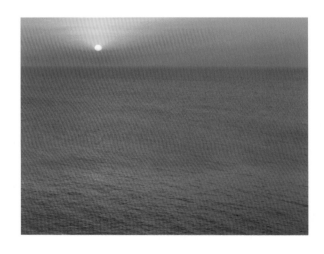
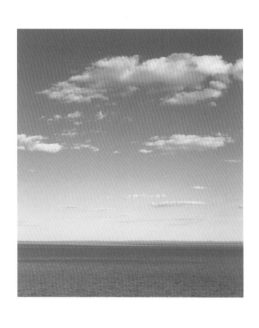

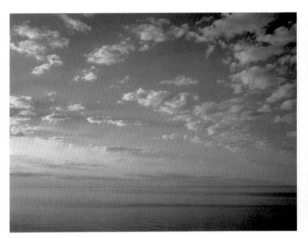

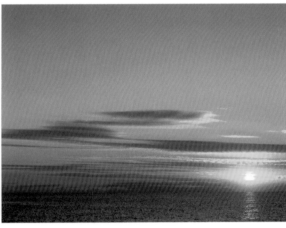

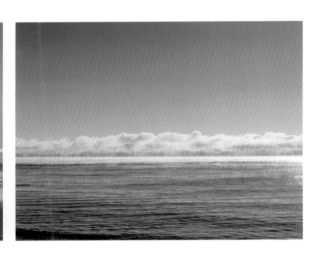

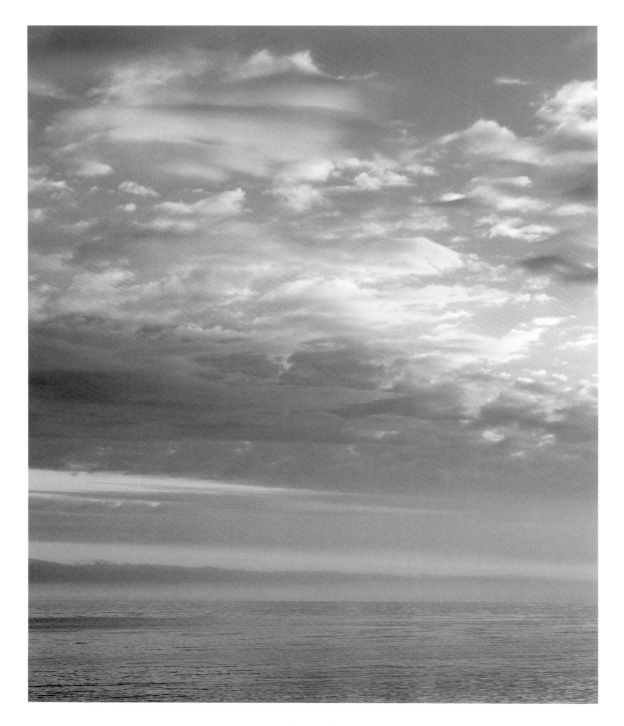

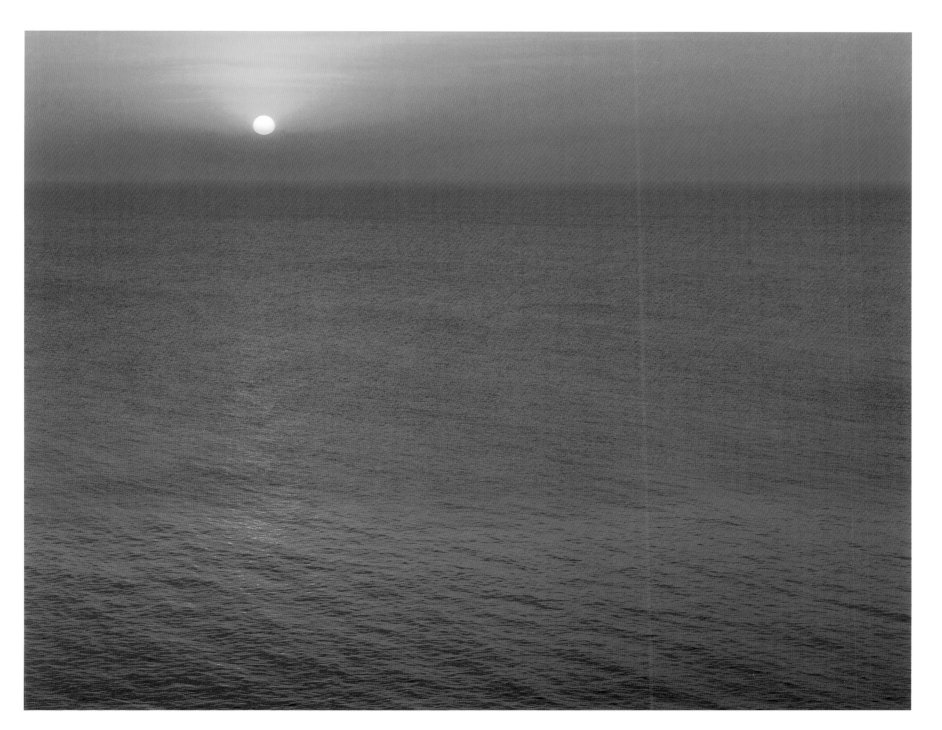

11 — 2

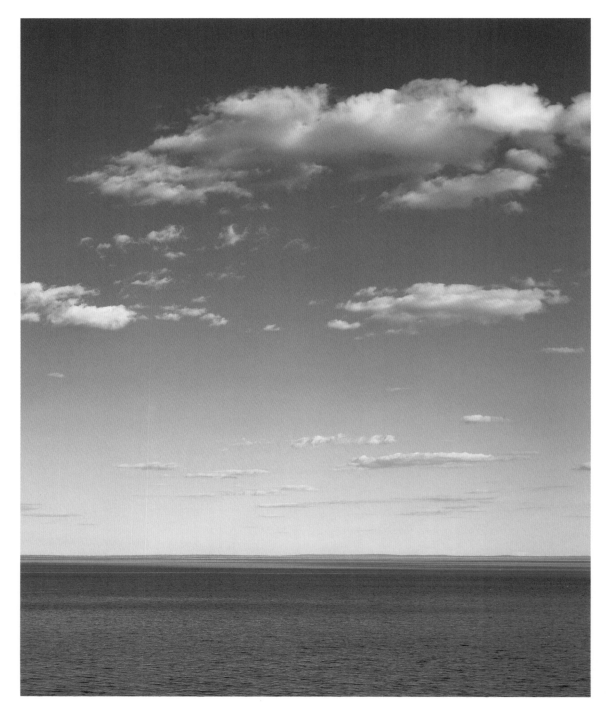

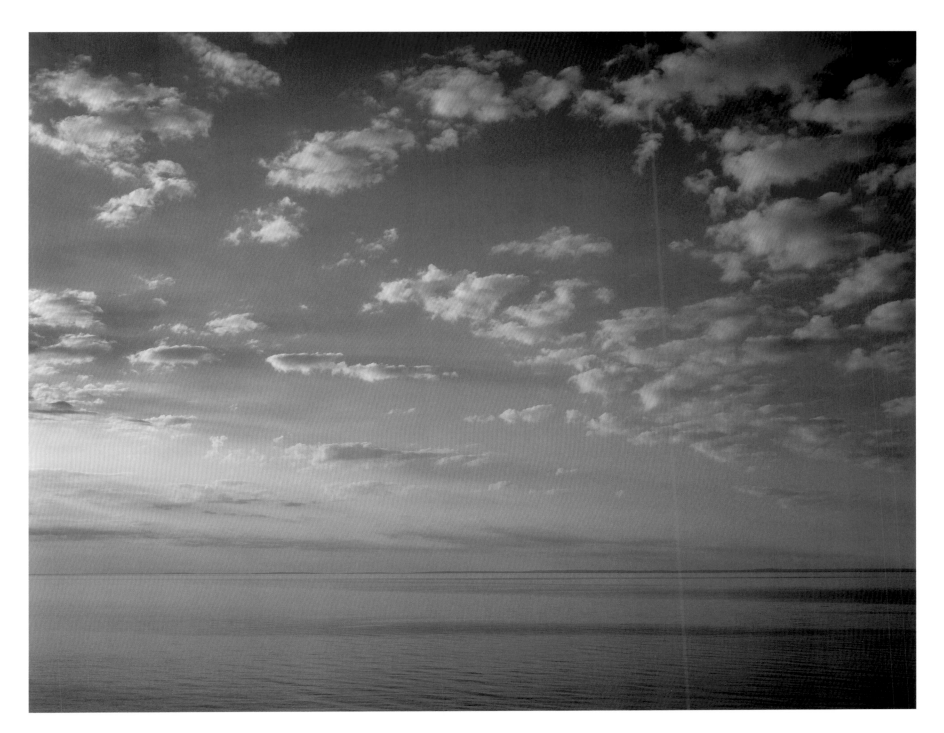

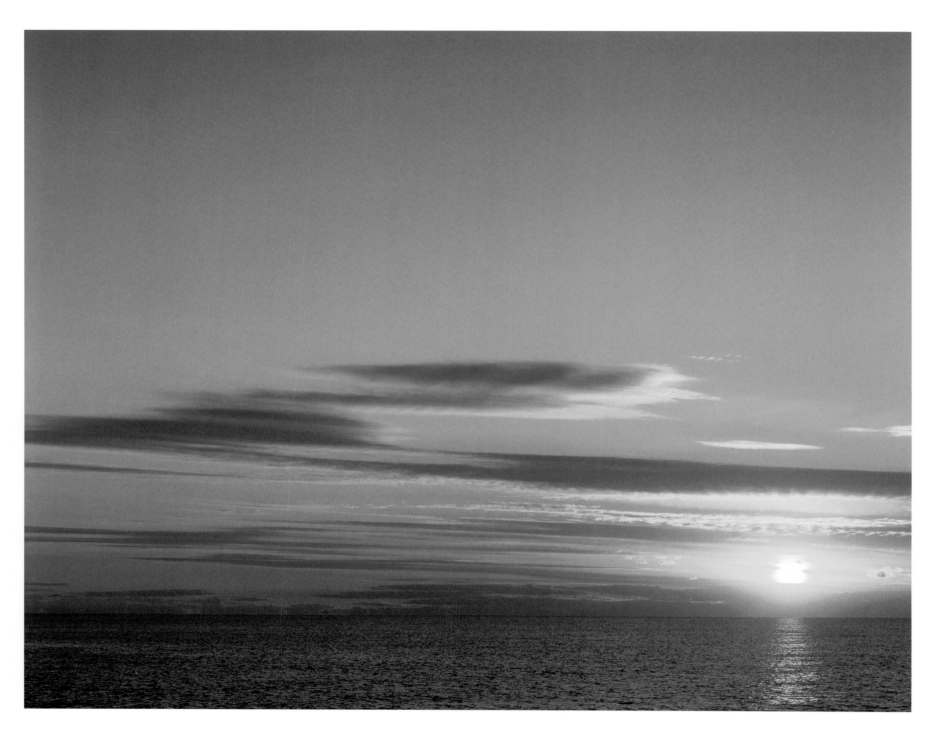

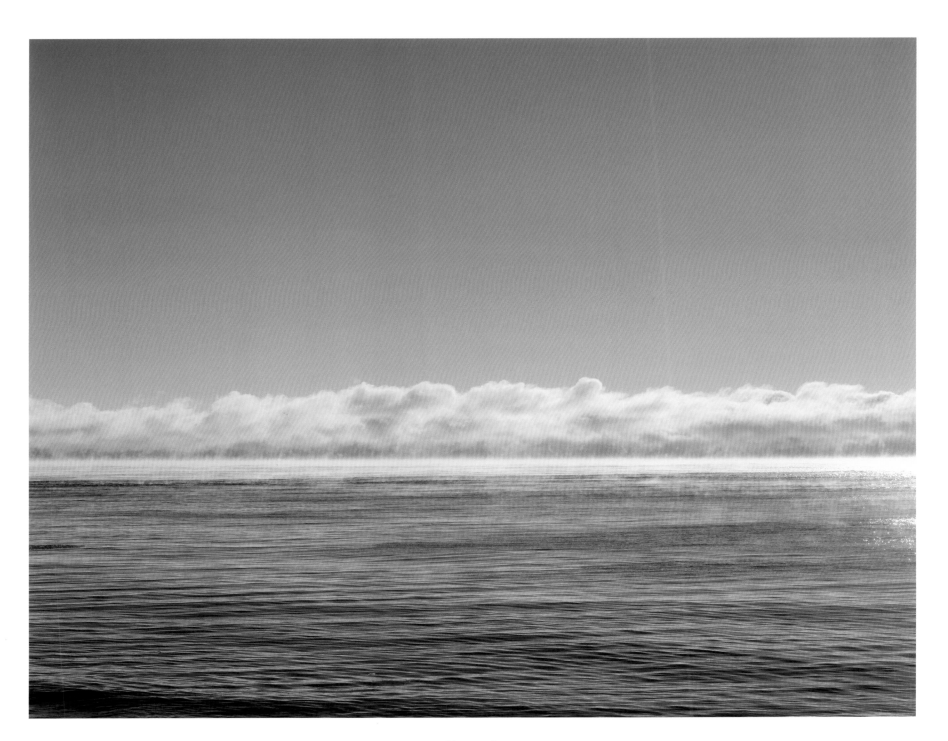

II — 6

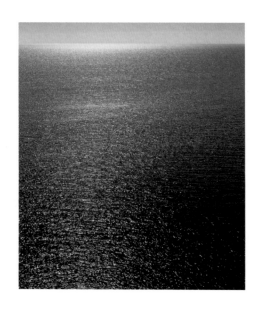

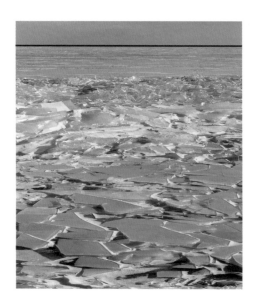

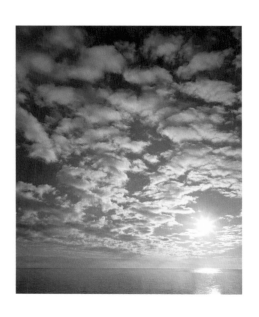

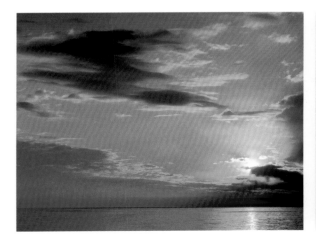
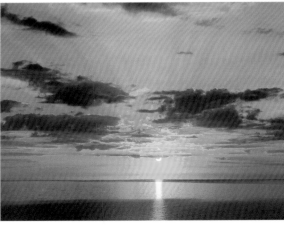
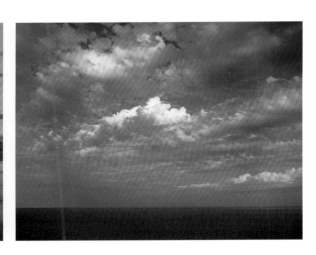

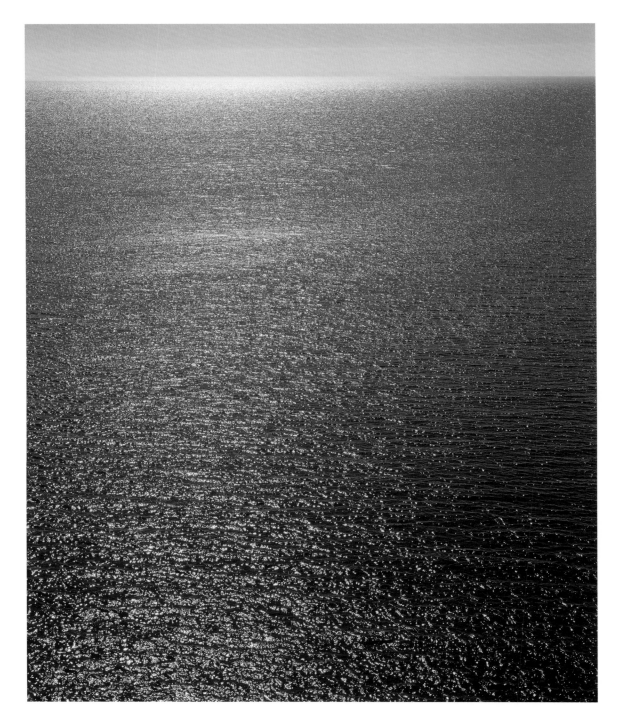

III — 1

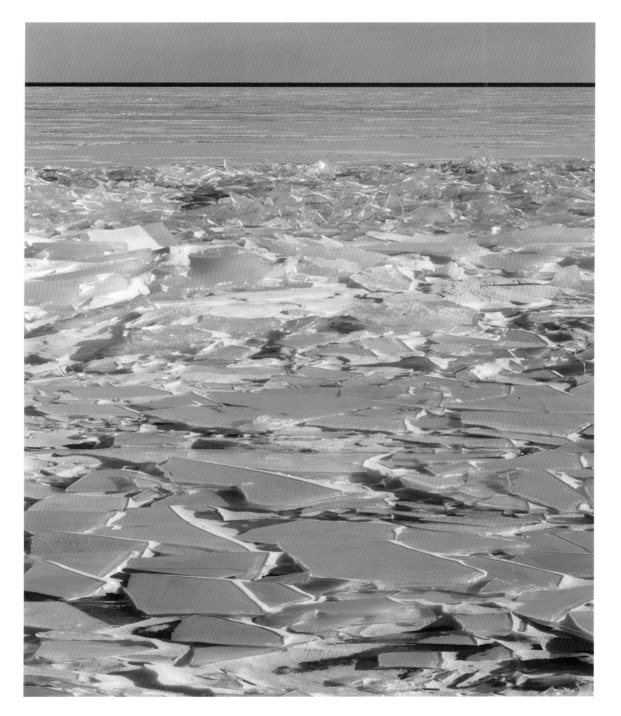

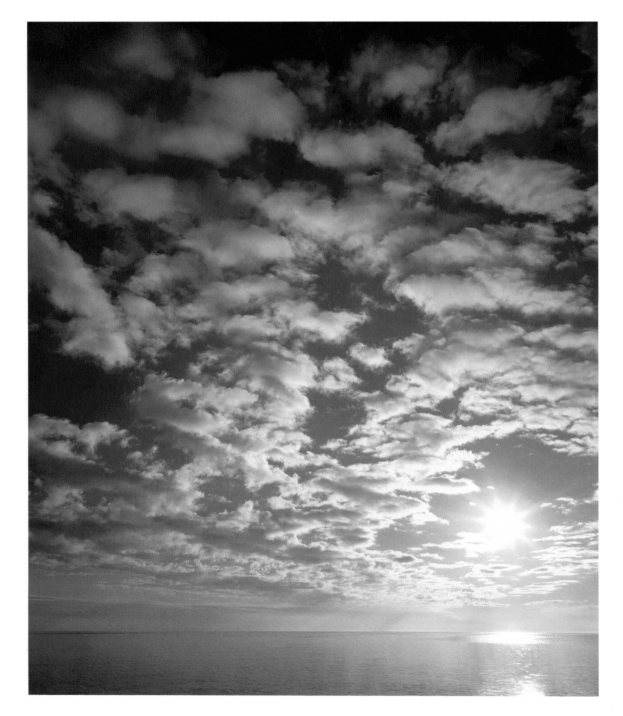

III — 3

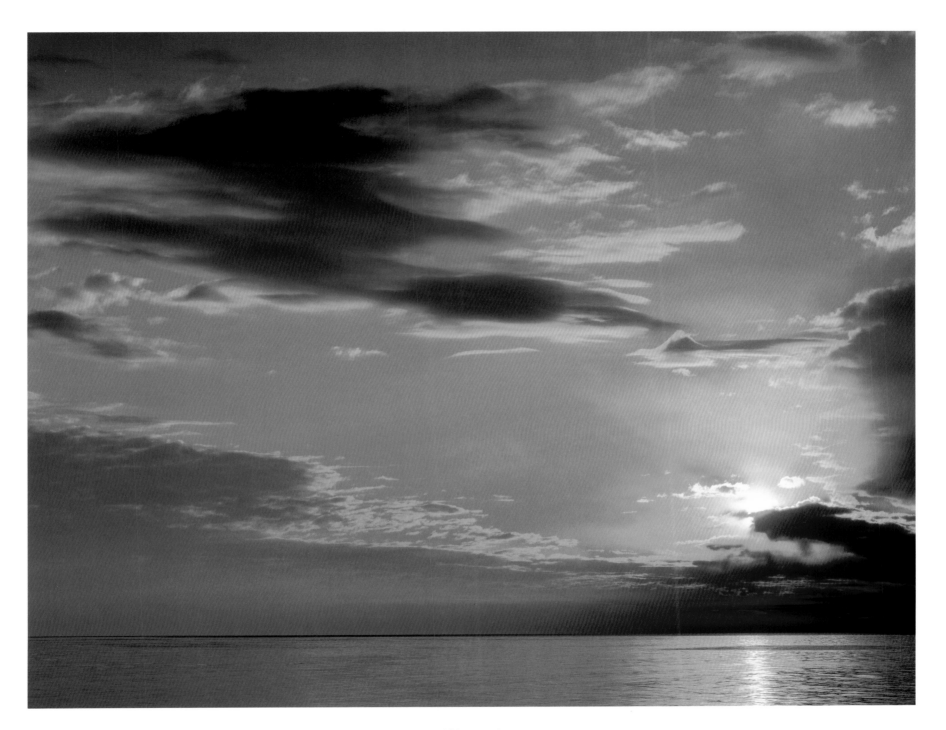

III — 4

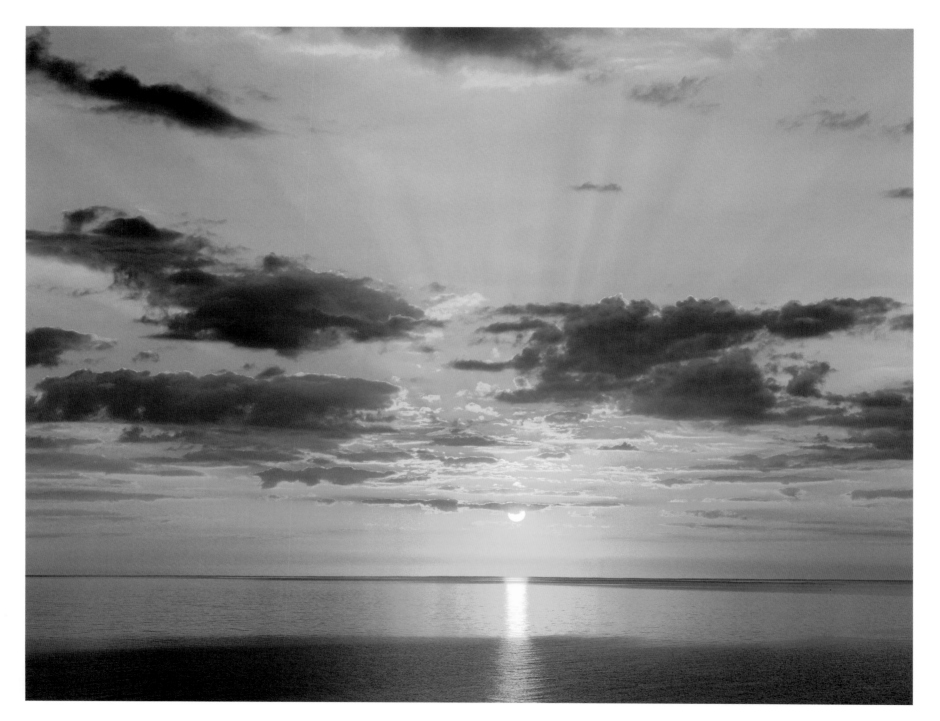

III — 5

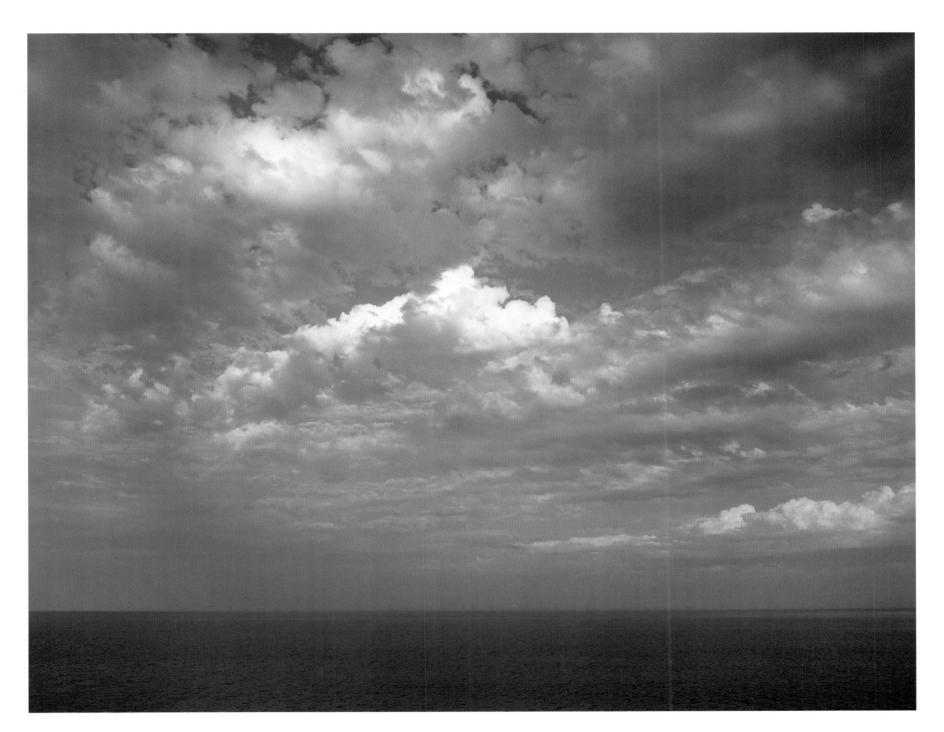

III — 6

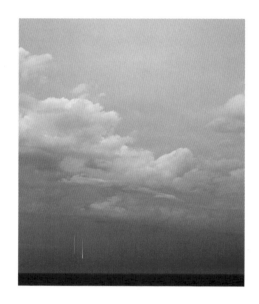
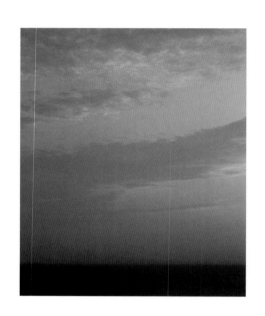
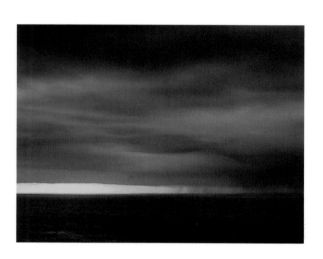

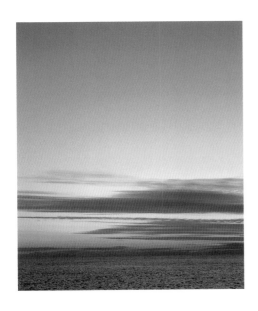

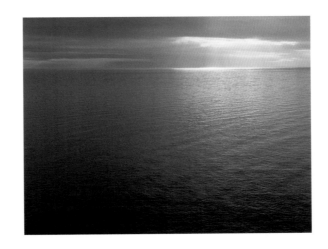

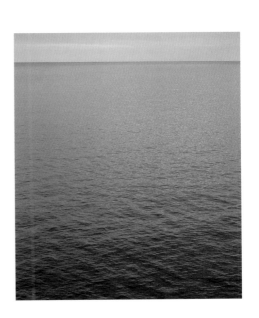

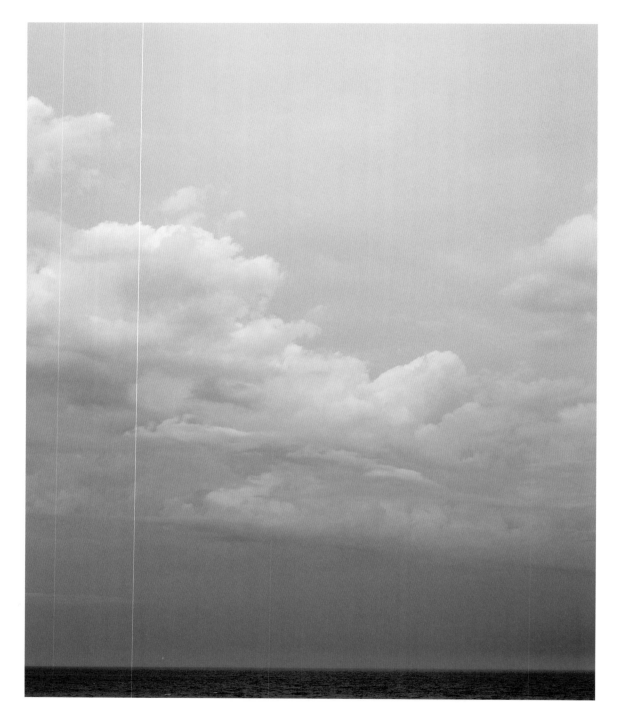

IV — 1

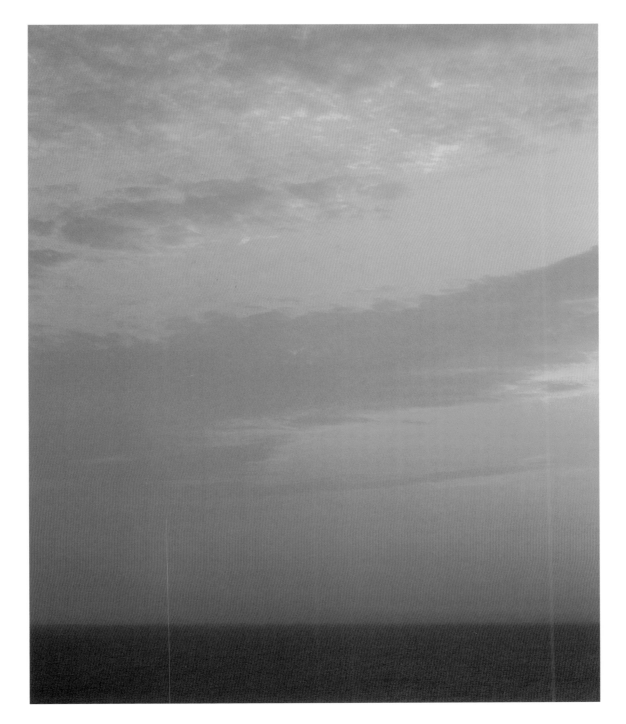

IV — 2

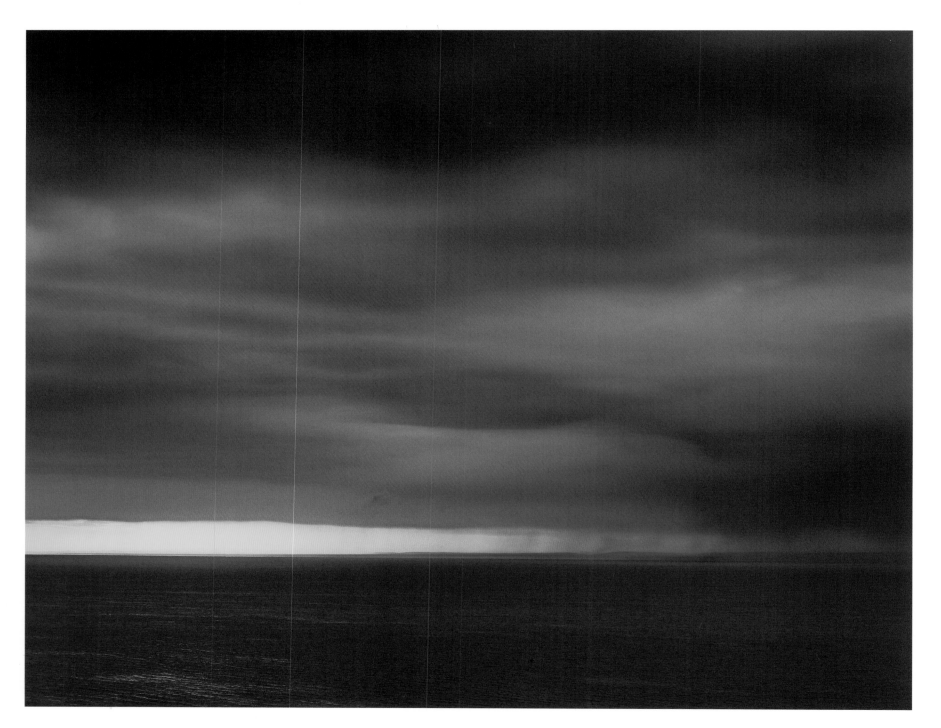

IV — 3

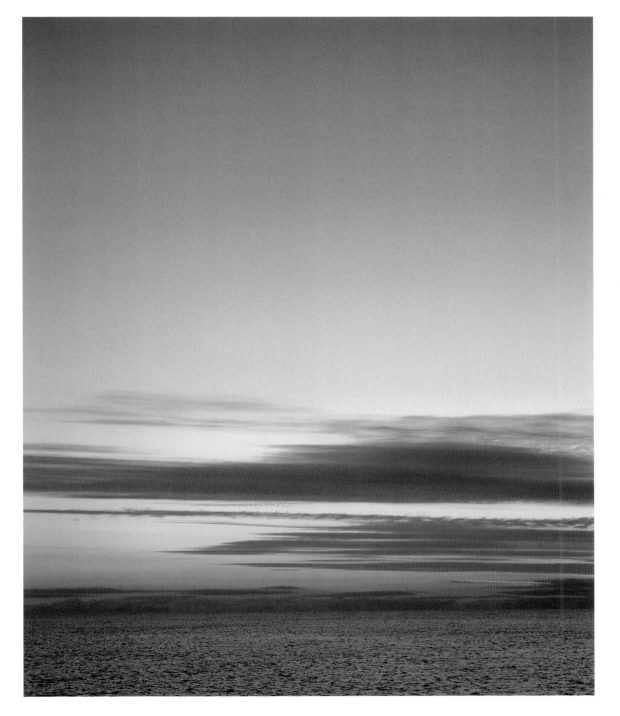

IV — 4

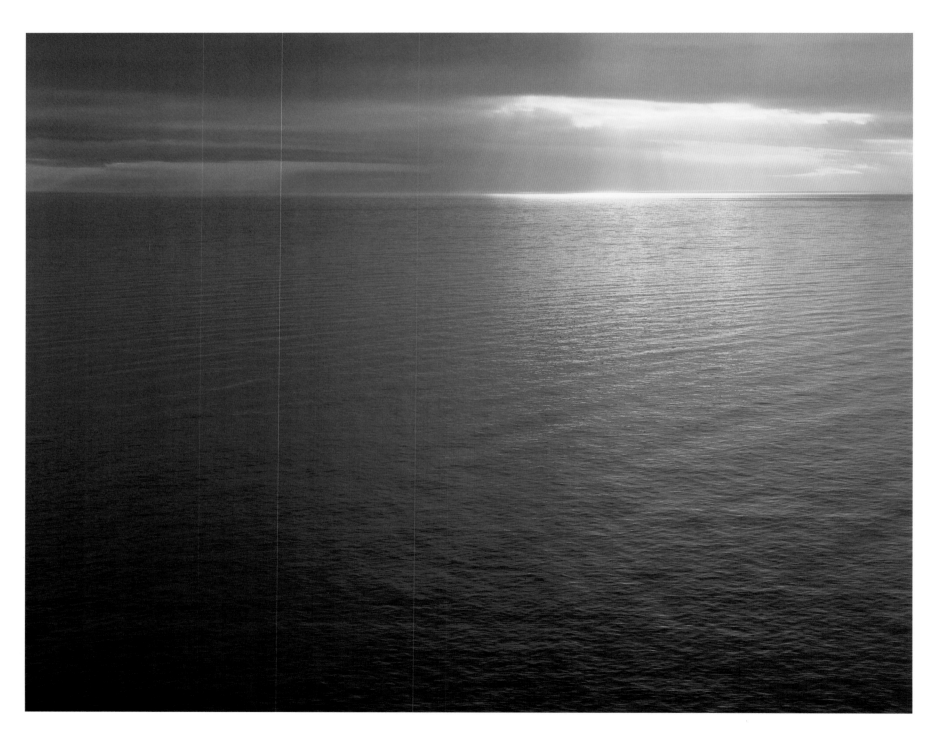

IV — 5

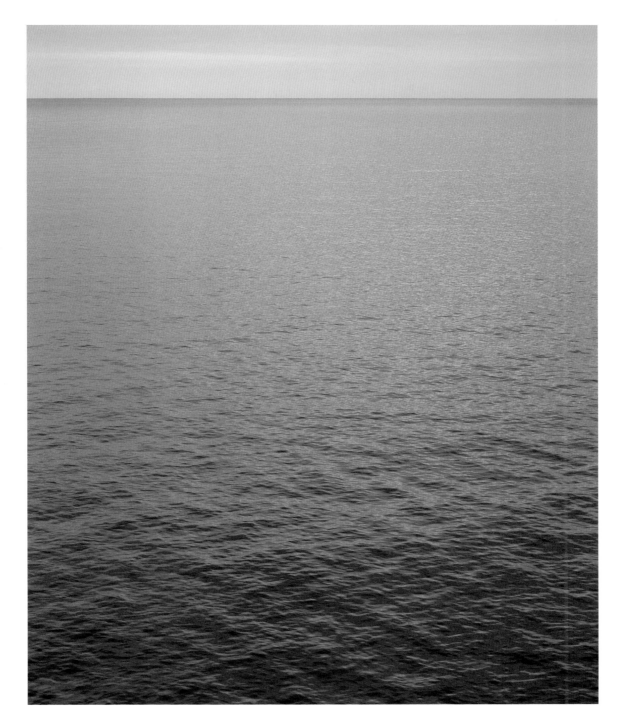

IV — 6

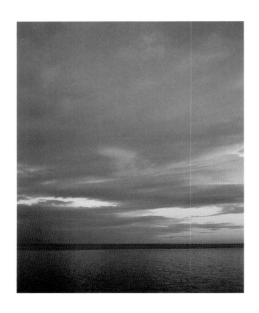
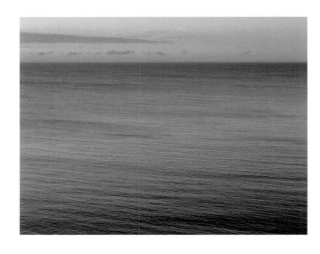
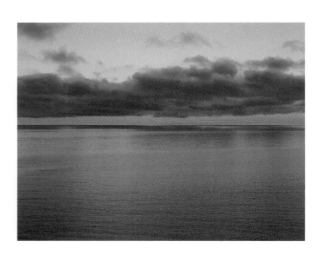

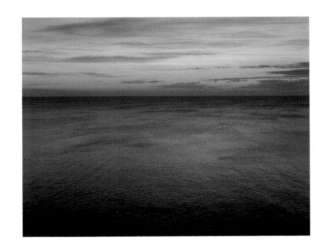
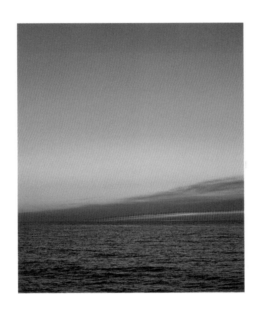
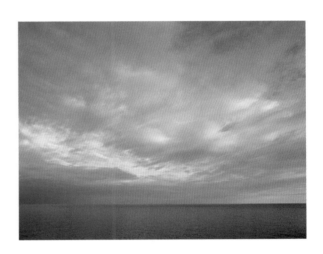

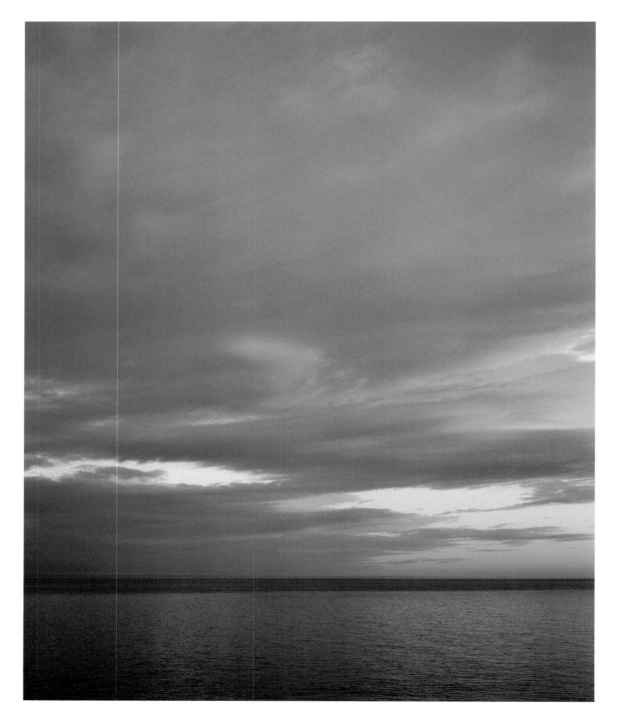

V — 1

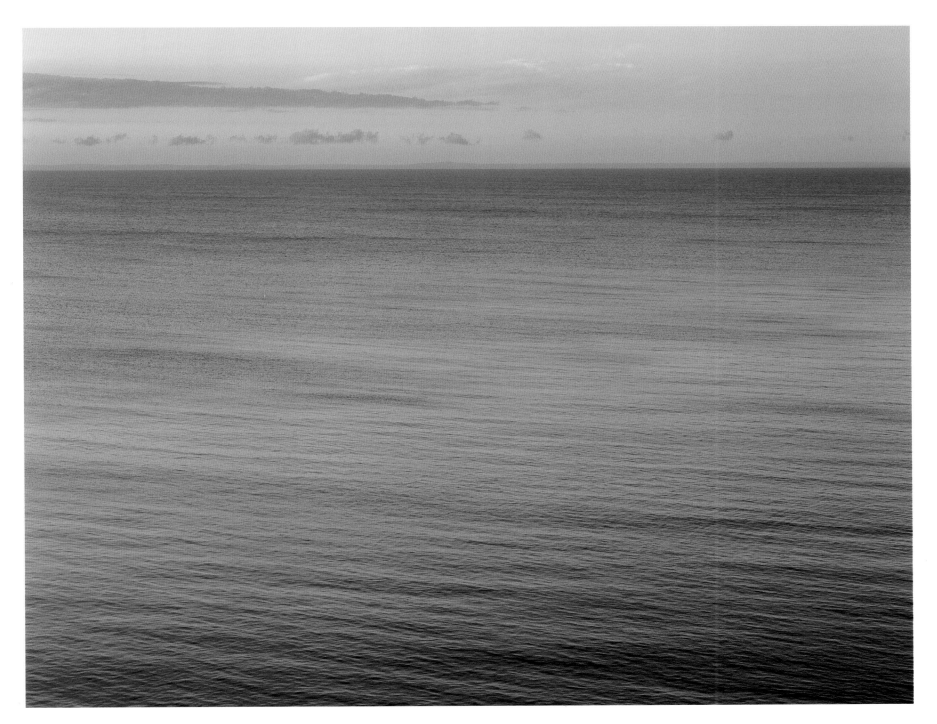

V — 2

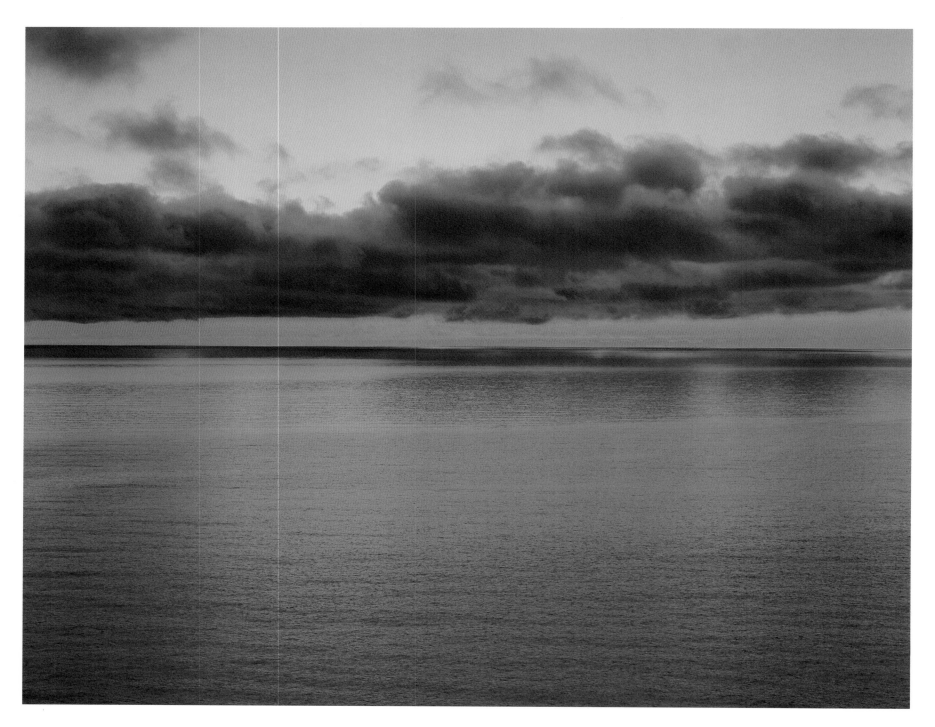

V — 3

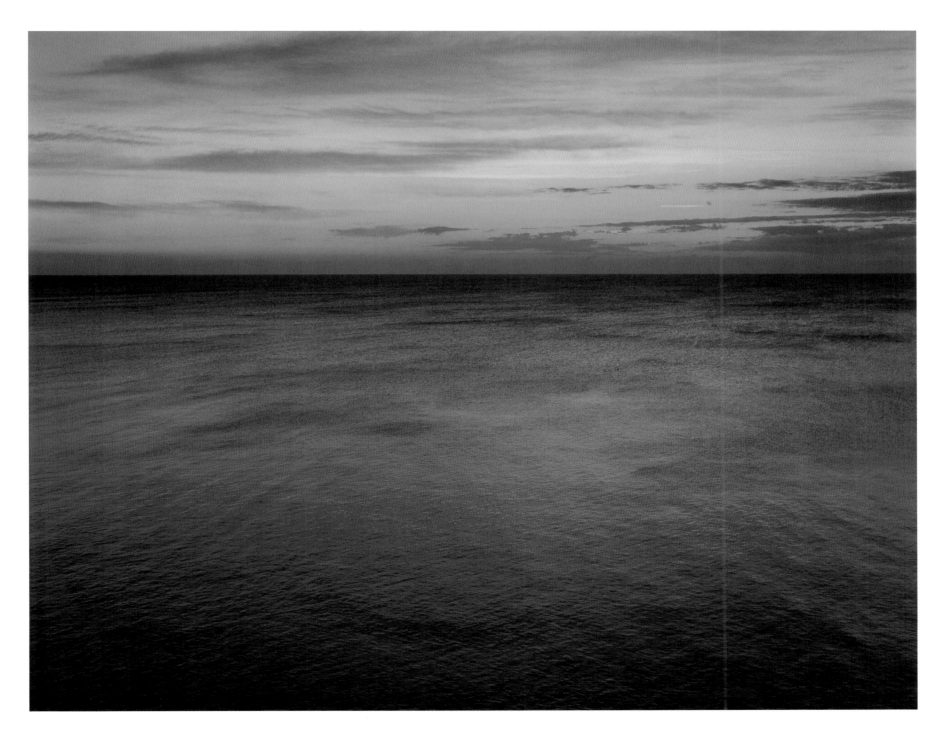

V — 4

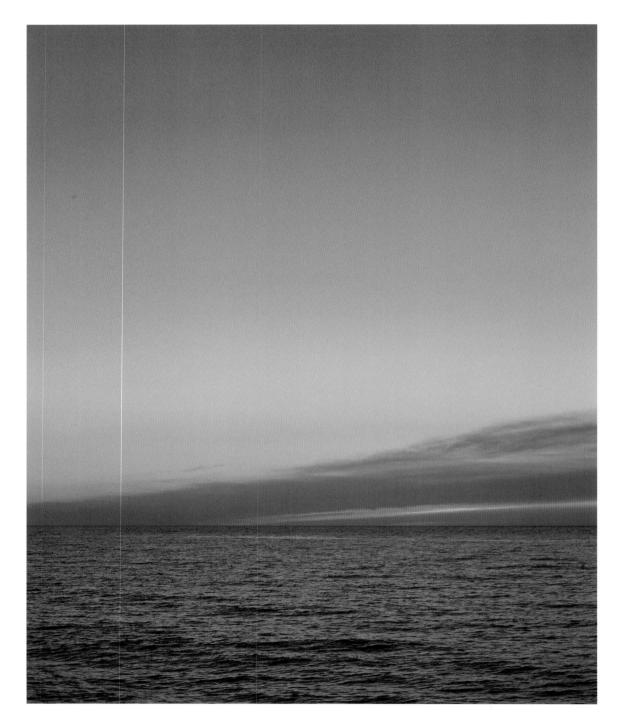

V — 5

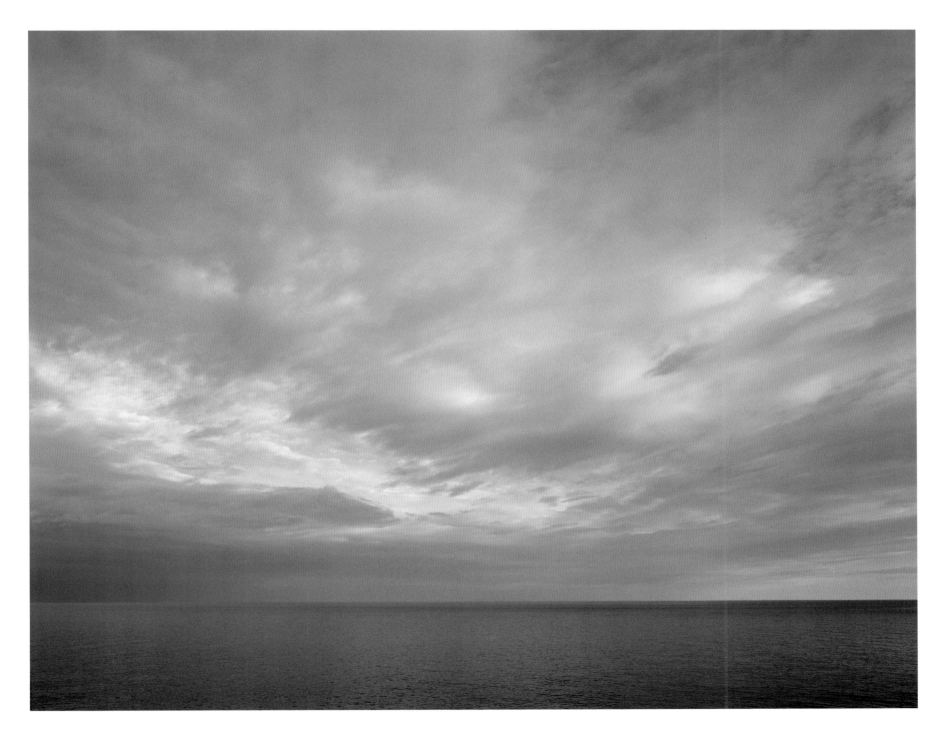

V — 6

BLACKLOCK • HORIZONS

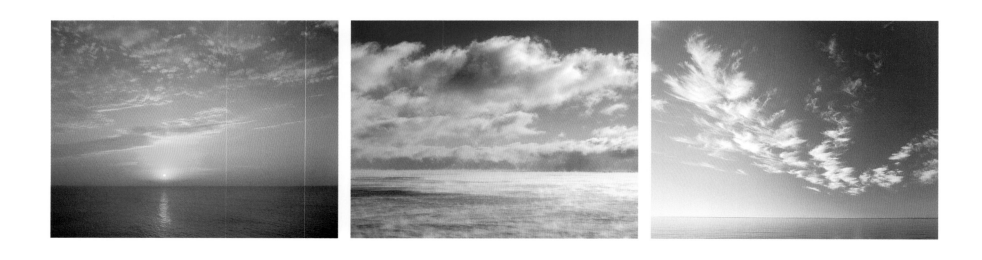

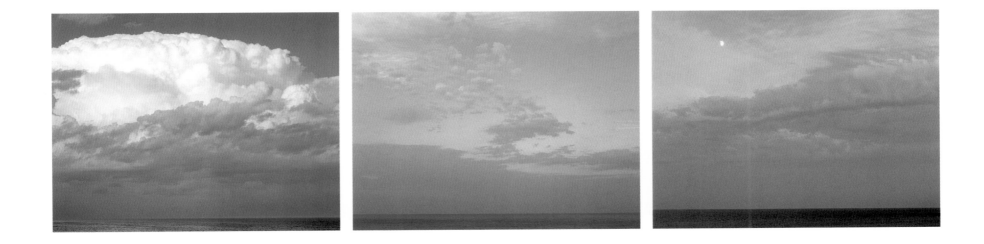

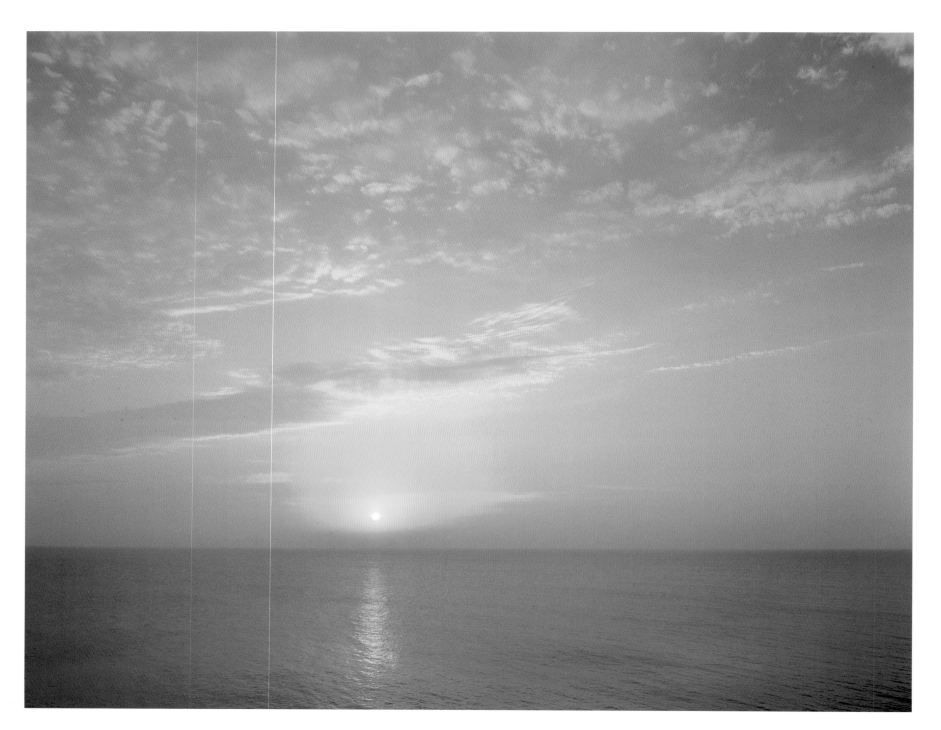

VI — I

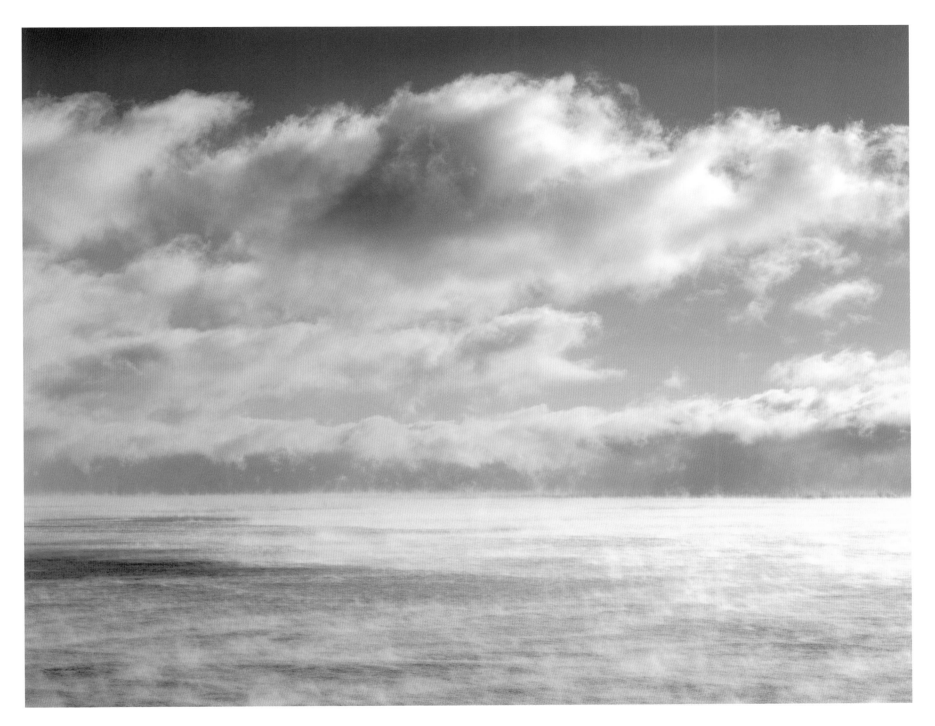

VI — 2

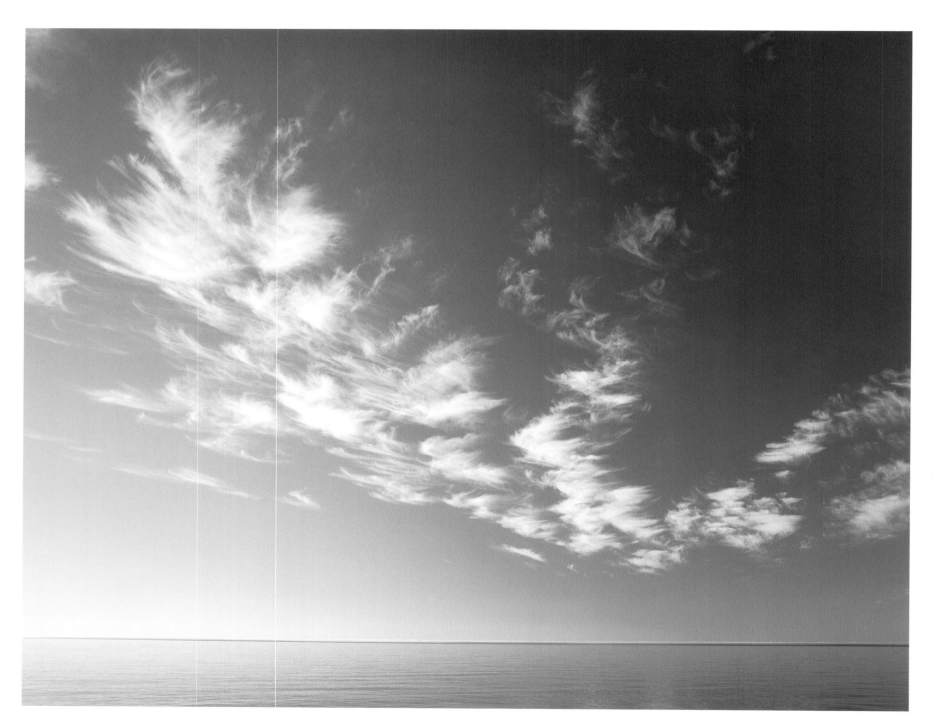

VI — 3

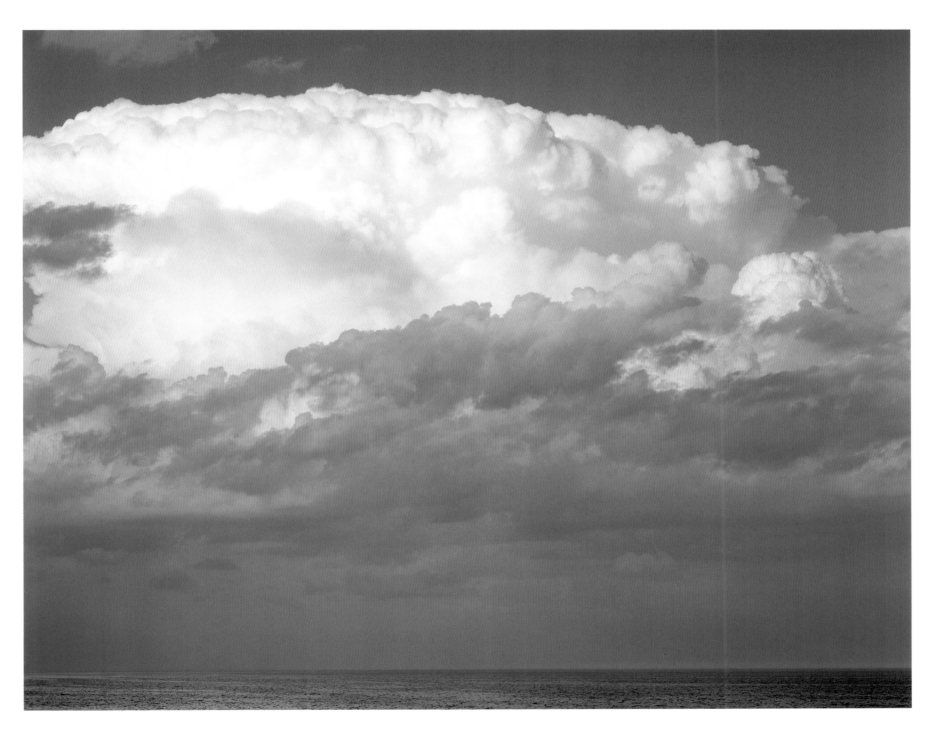

VI — 4

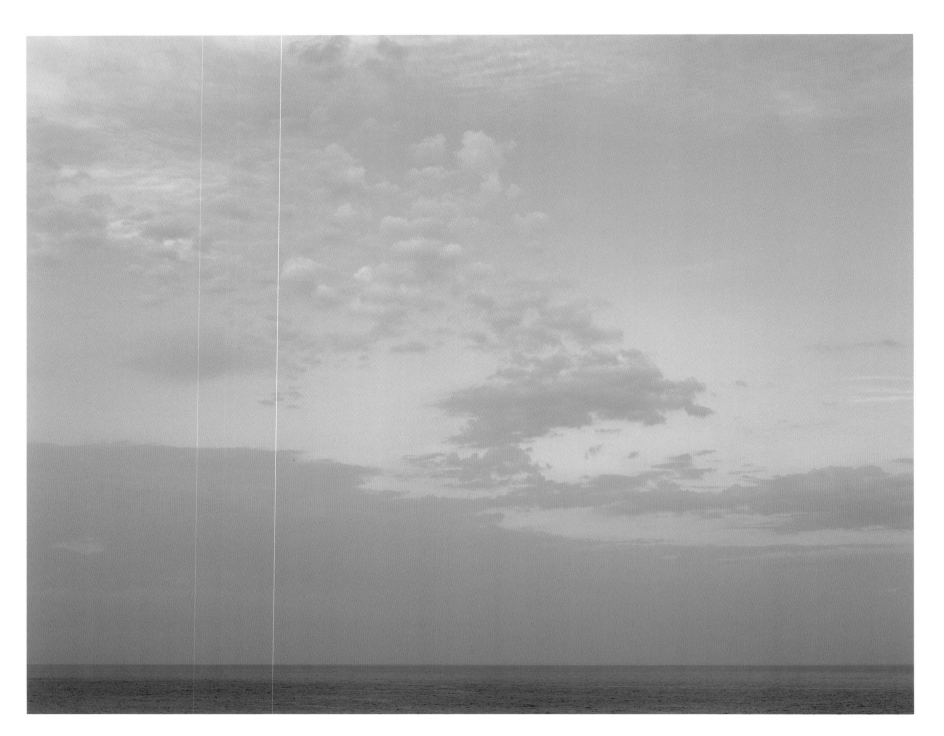

VI — 5

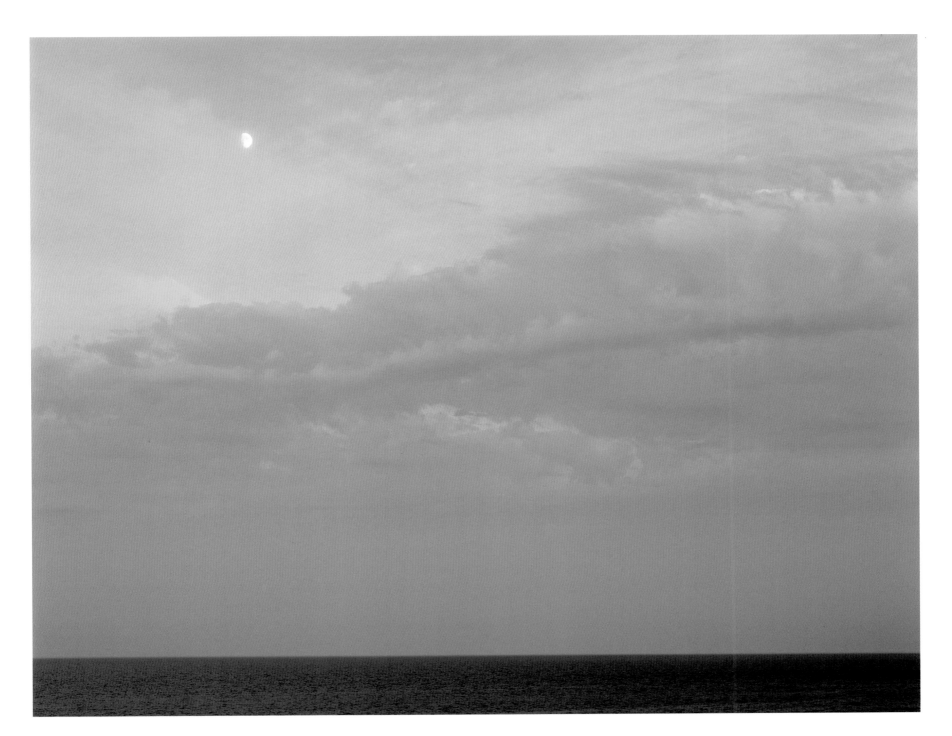

VI — 6

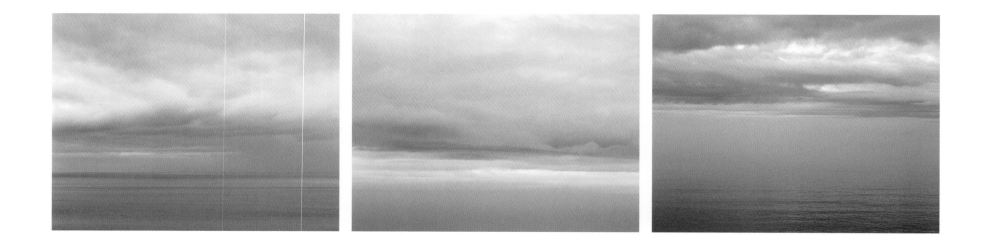

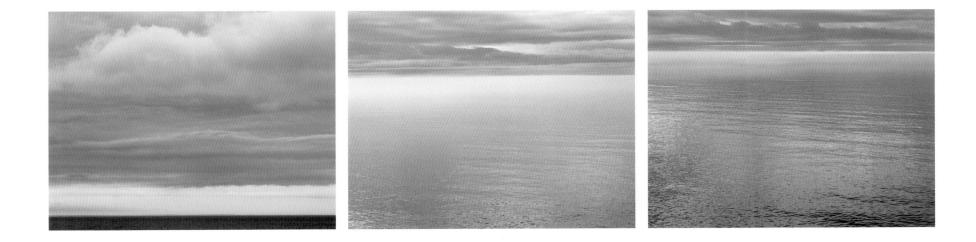

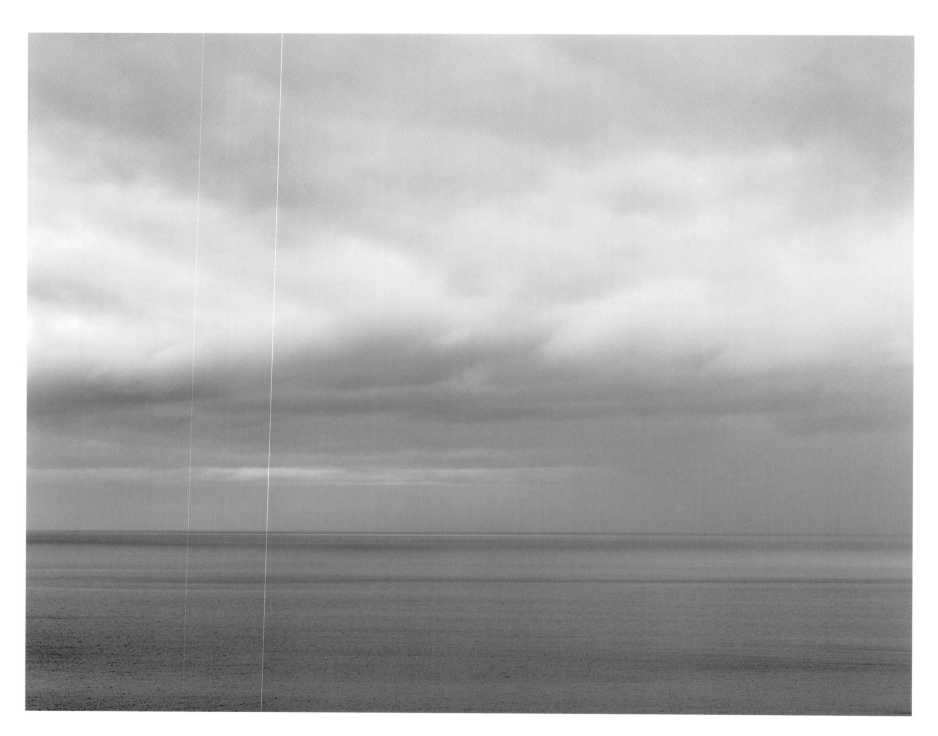

VII — 1

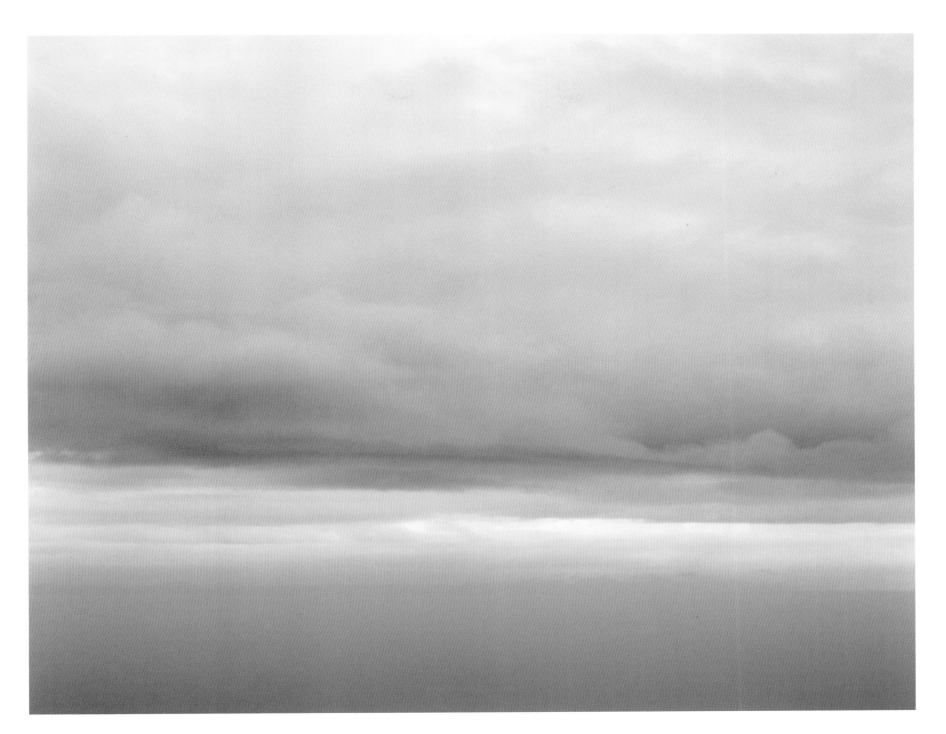

VII — 2

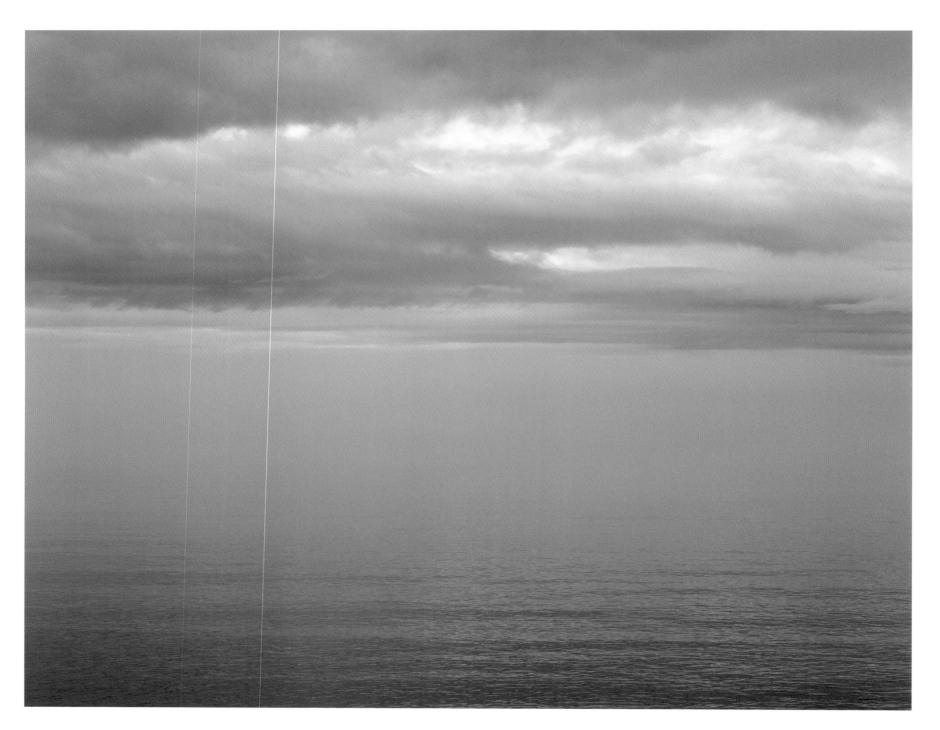

VII — 3

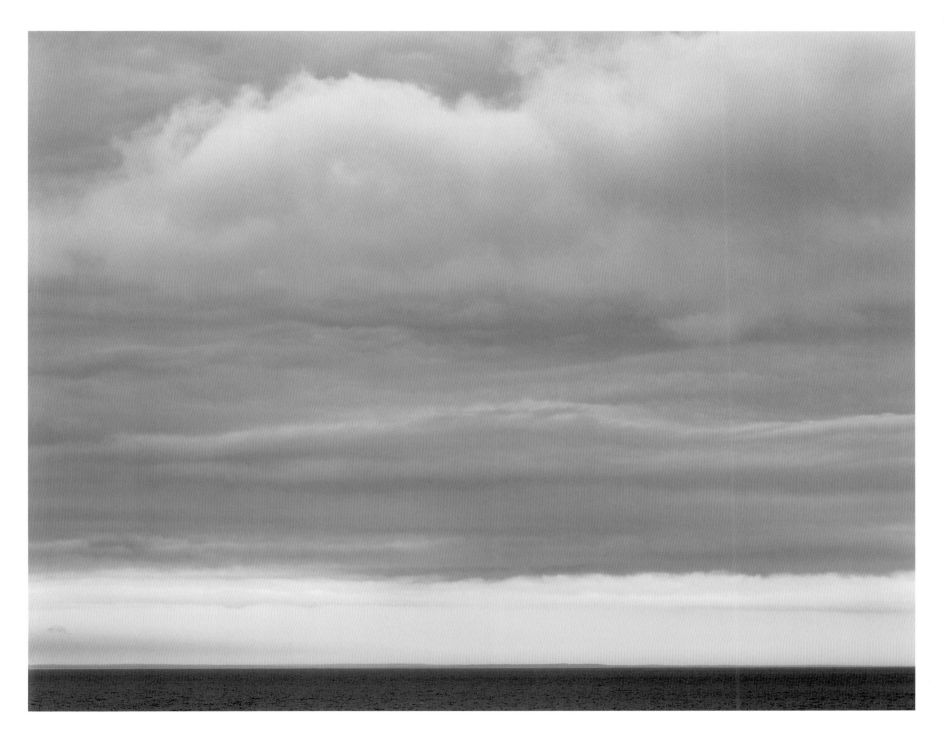

VII — 4

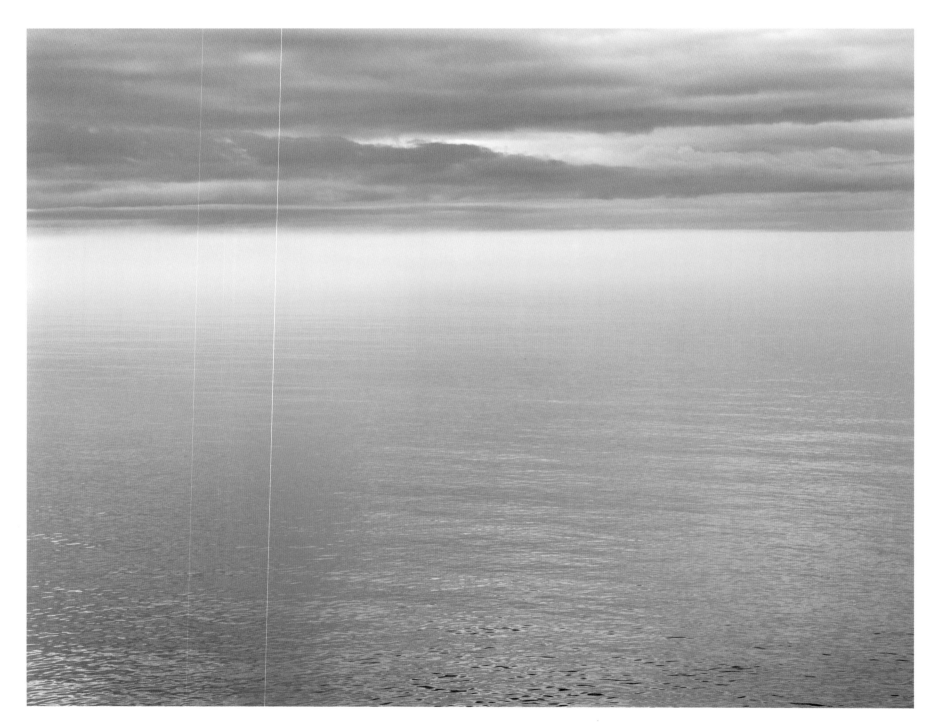

VII — 5

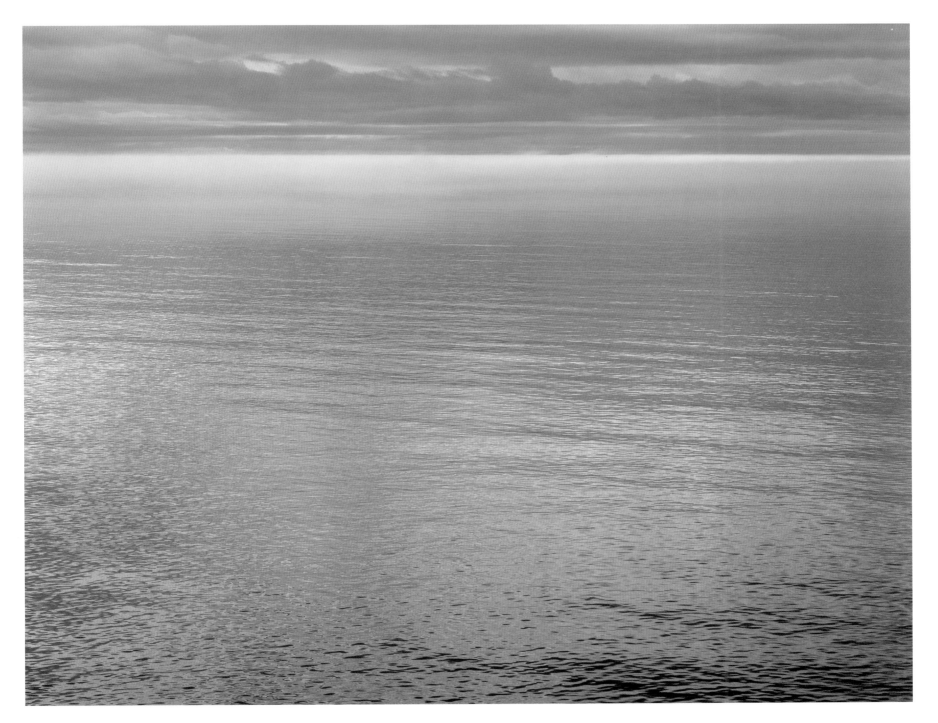

VII — 6

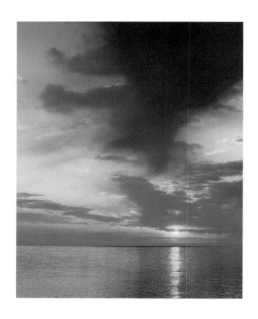
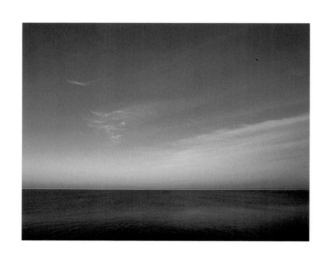
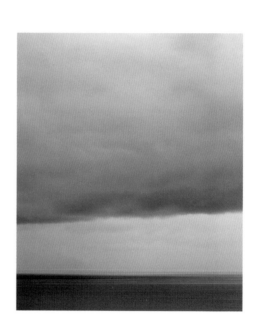

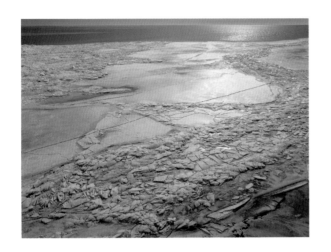

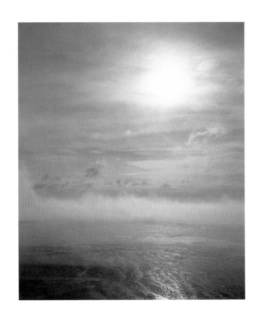

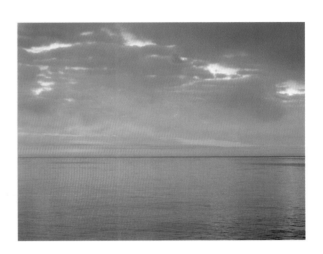

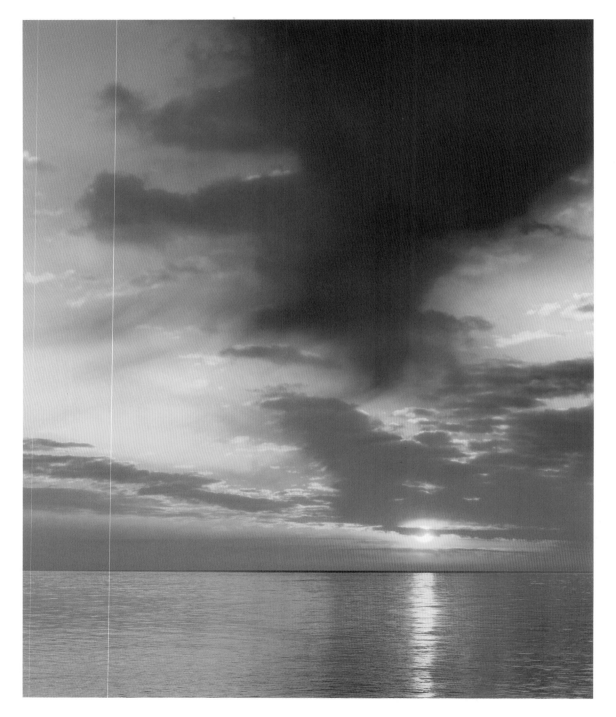

VIII — 1

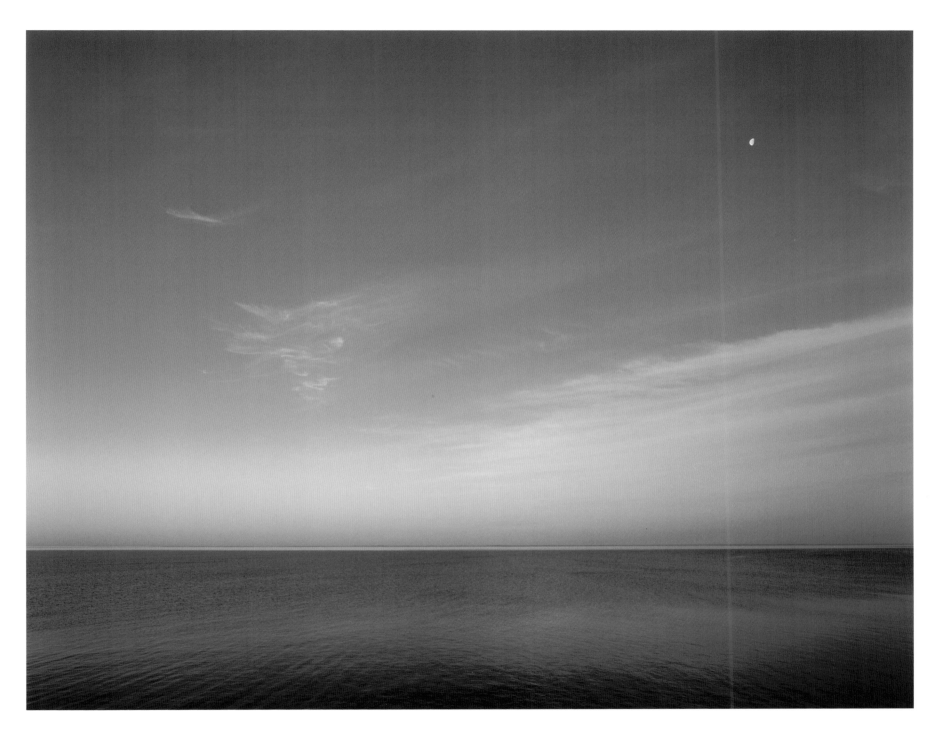

VIII — 2

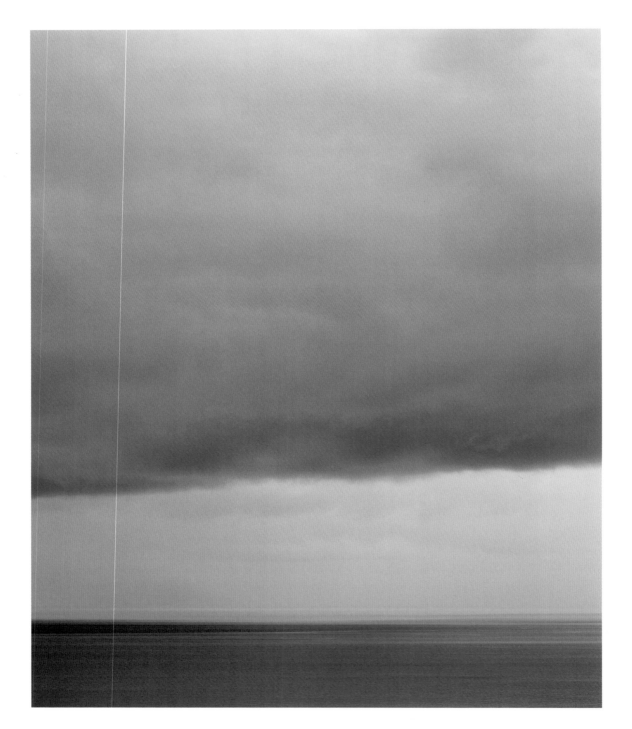

VIII — 3

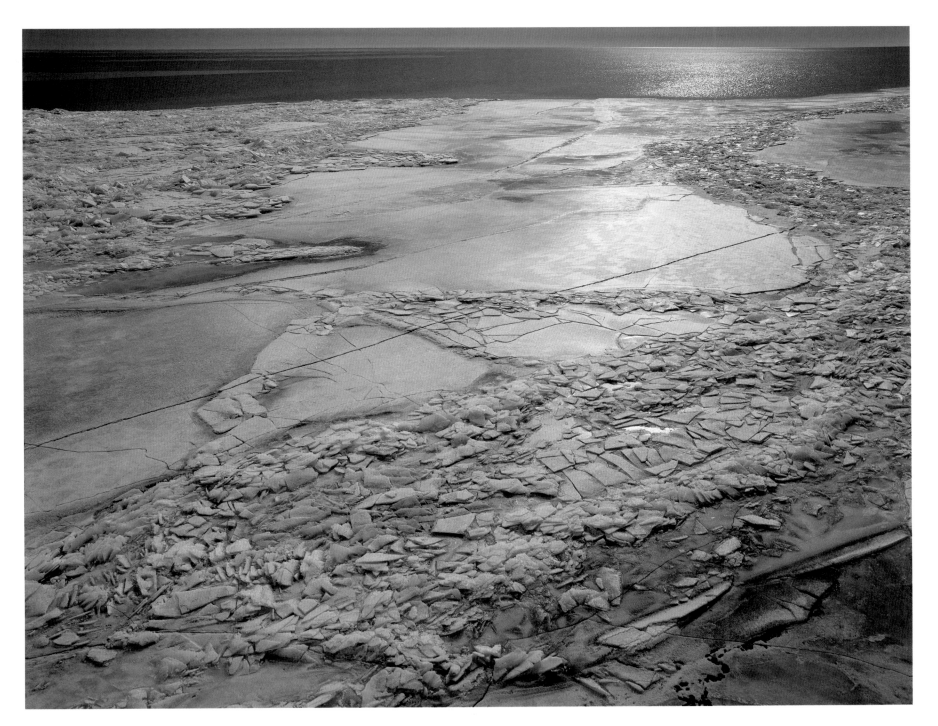

VIII — 4

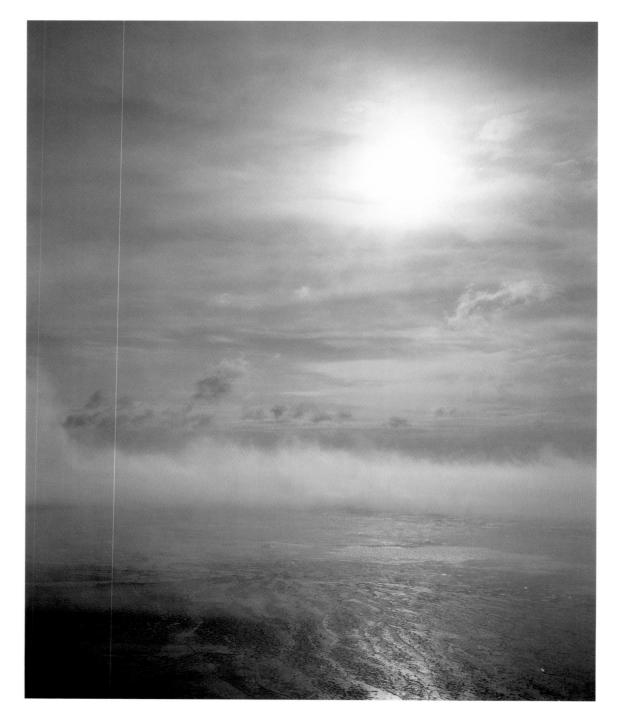

VIII — 5

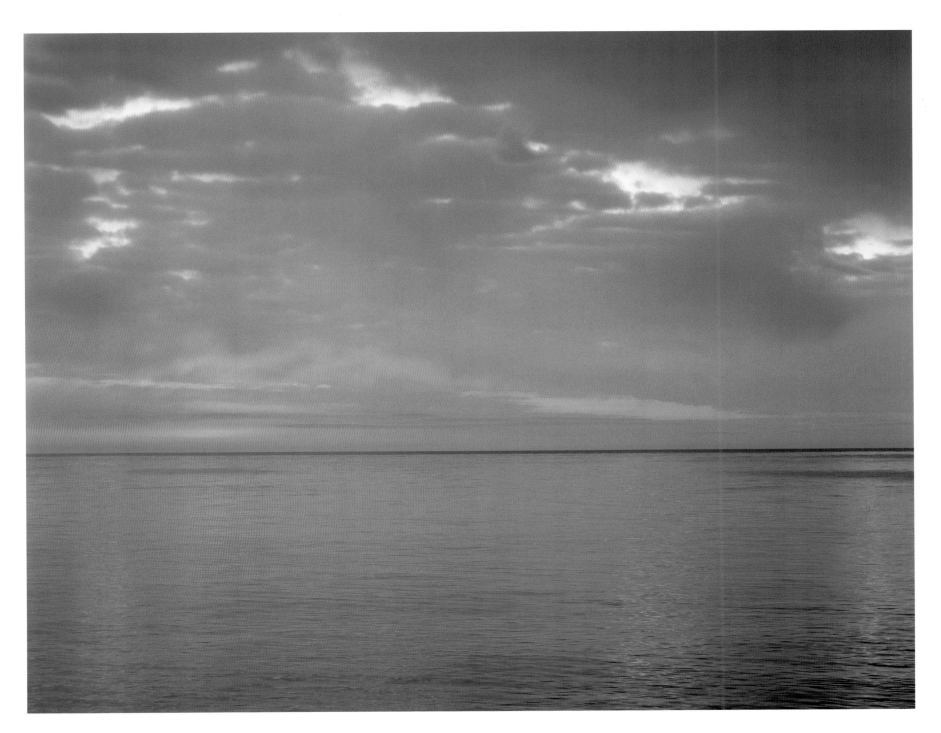

VIII — 6

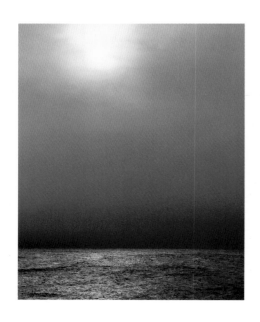
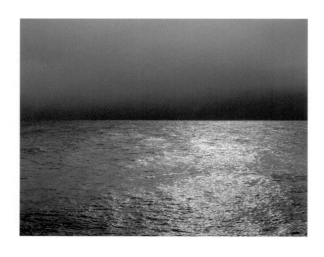
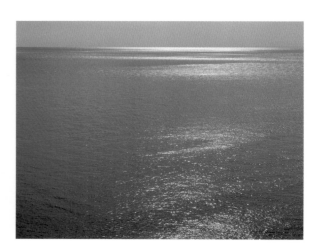

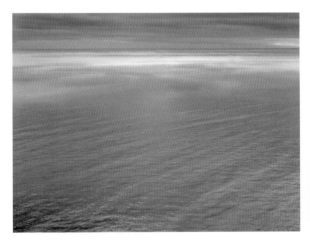
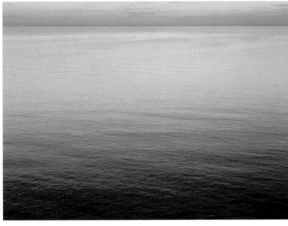
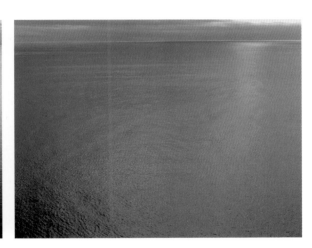

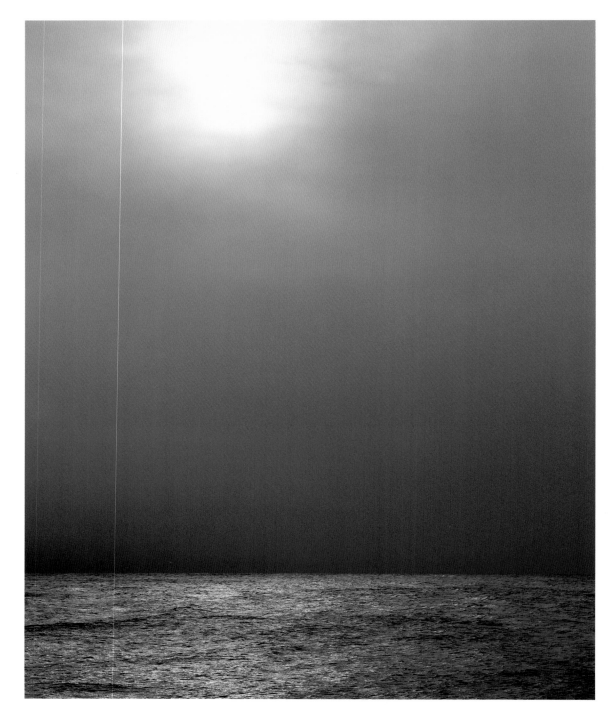

IX — 1

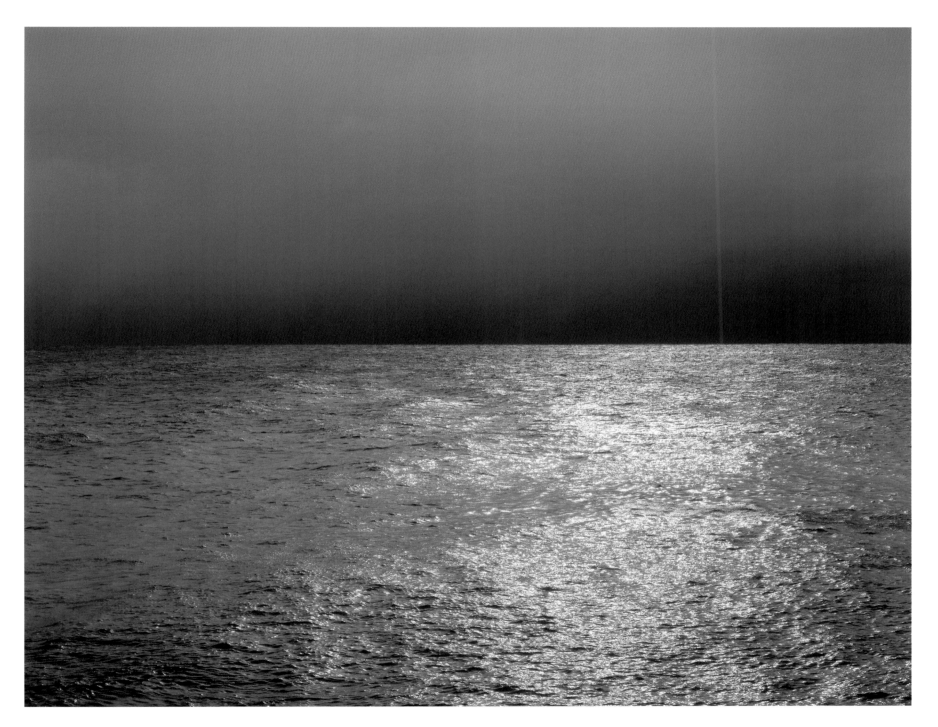

IX — 2

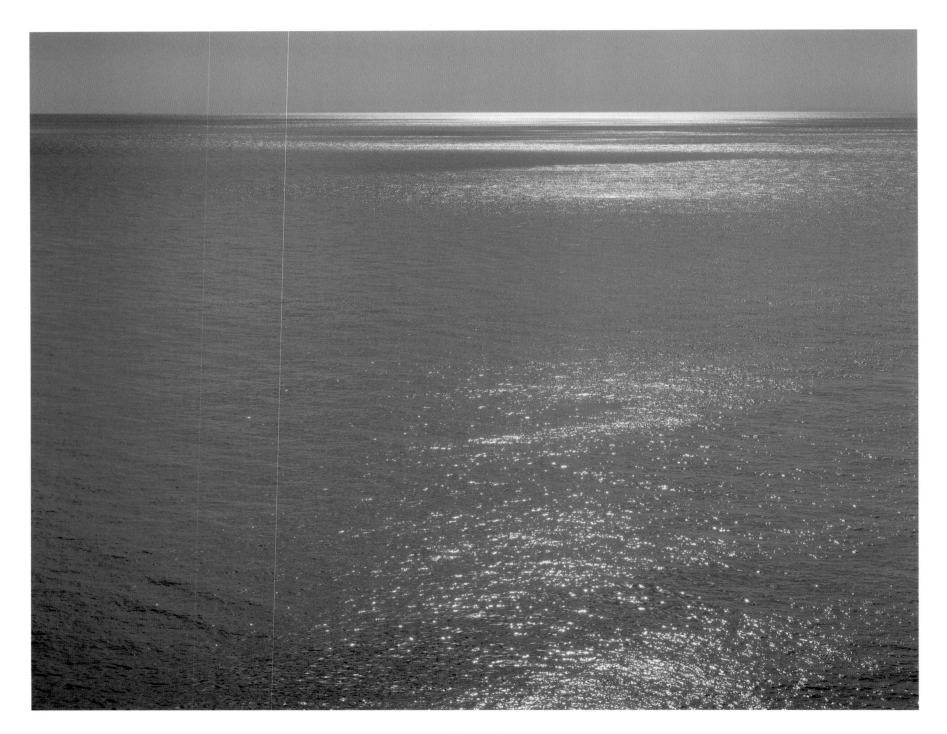

IX — 3

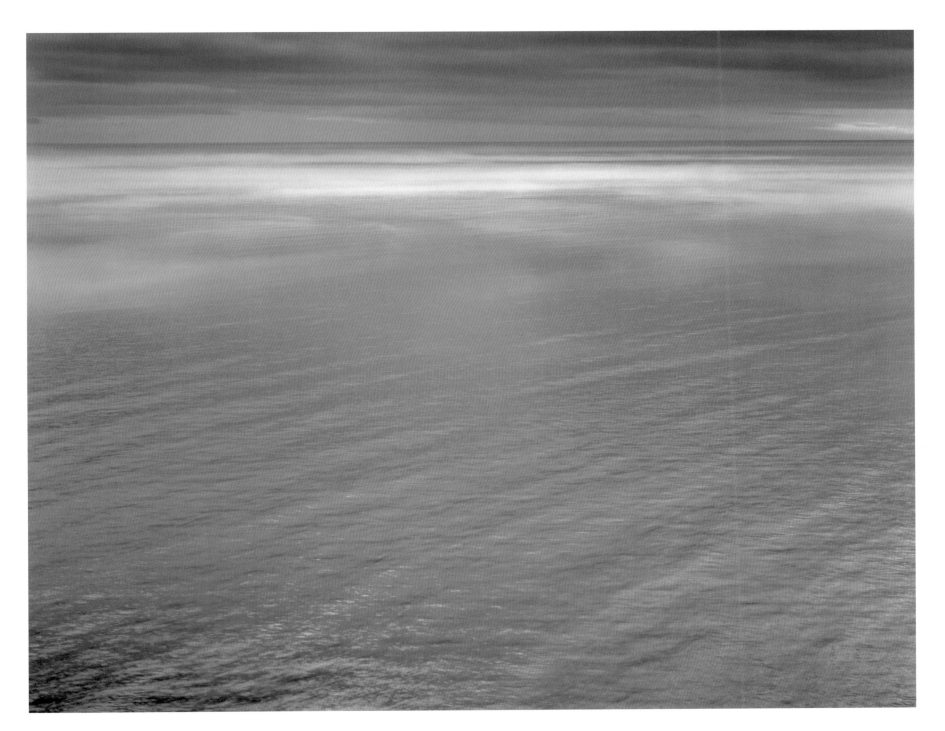

IX — 4

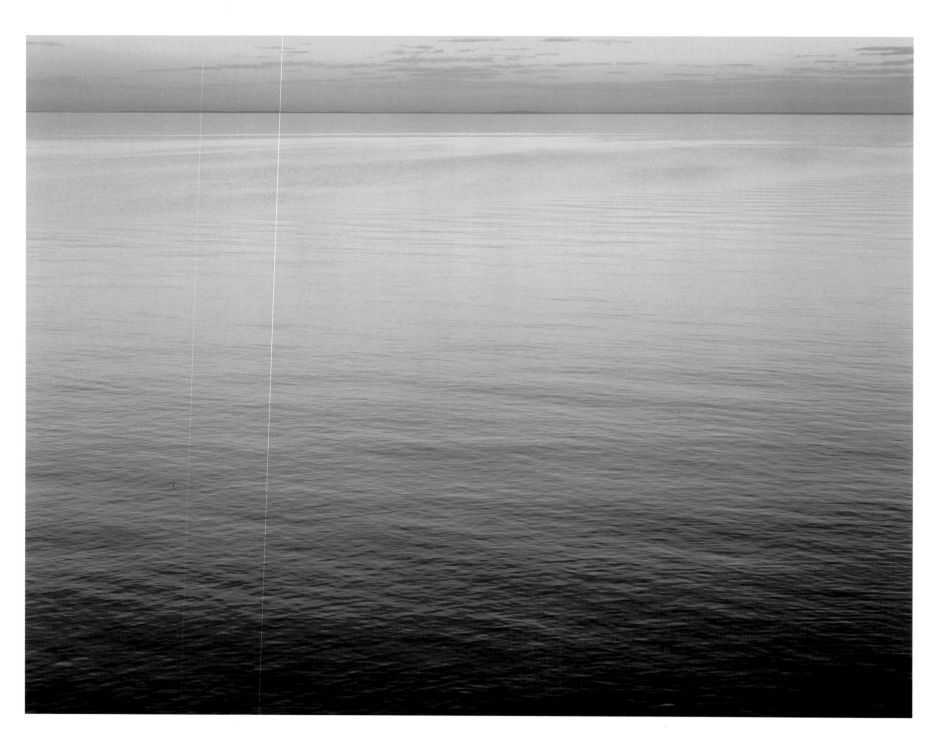

IX — 5

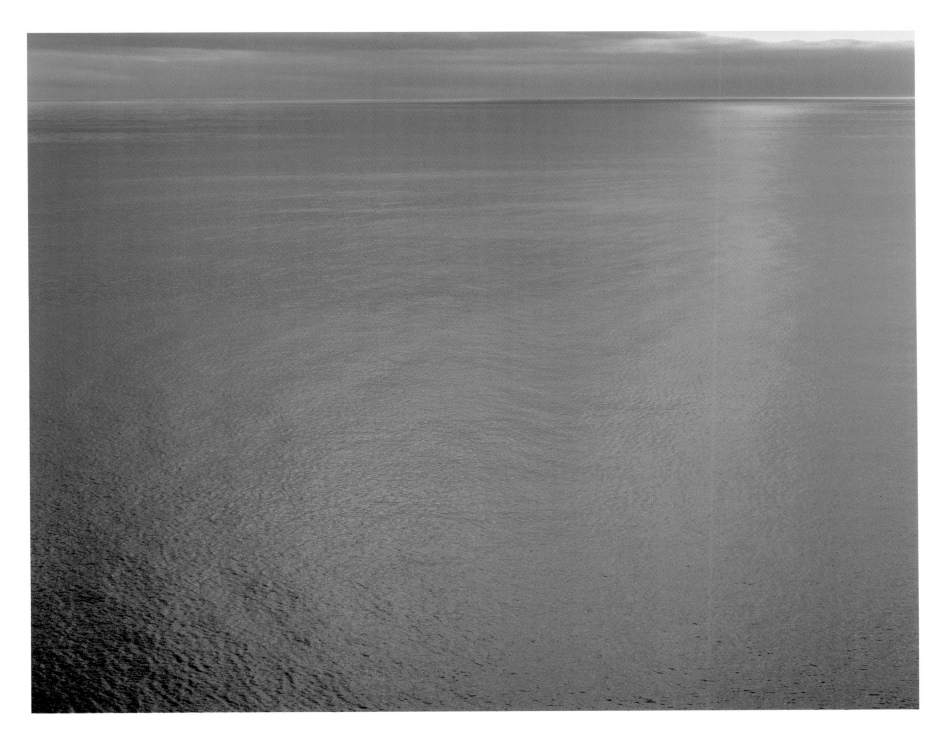

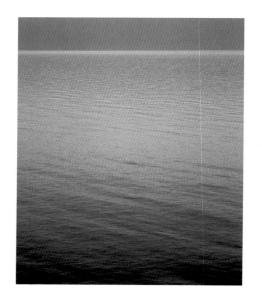

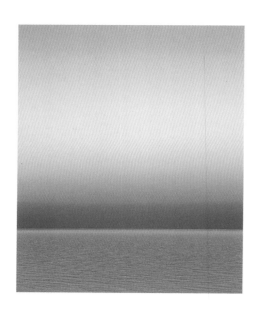

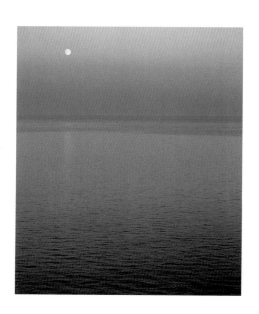

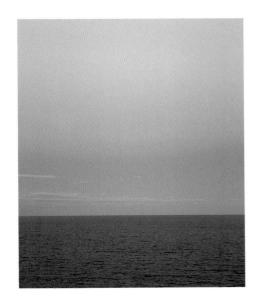
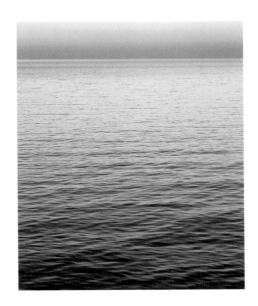
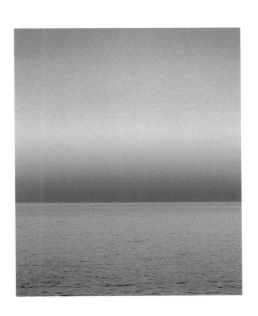

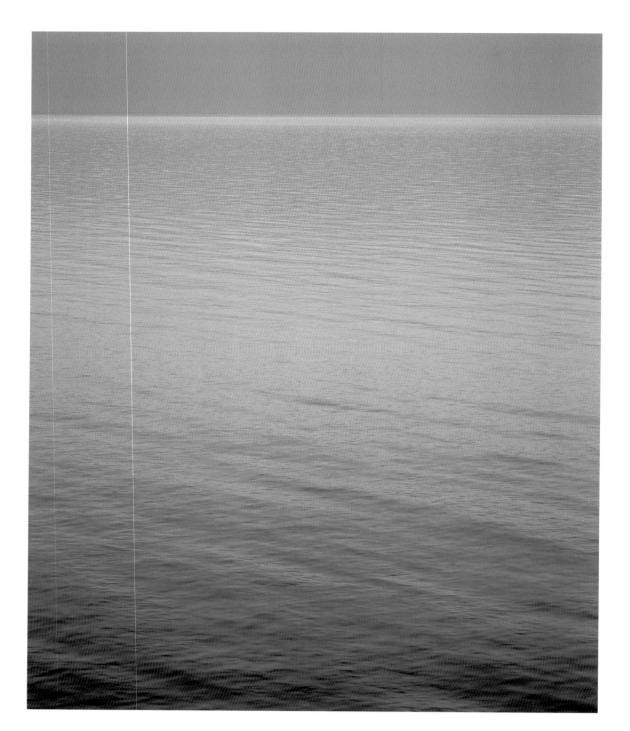

X — 1

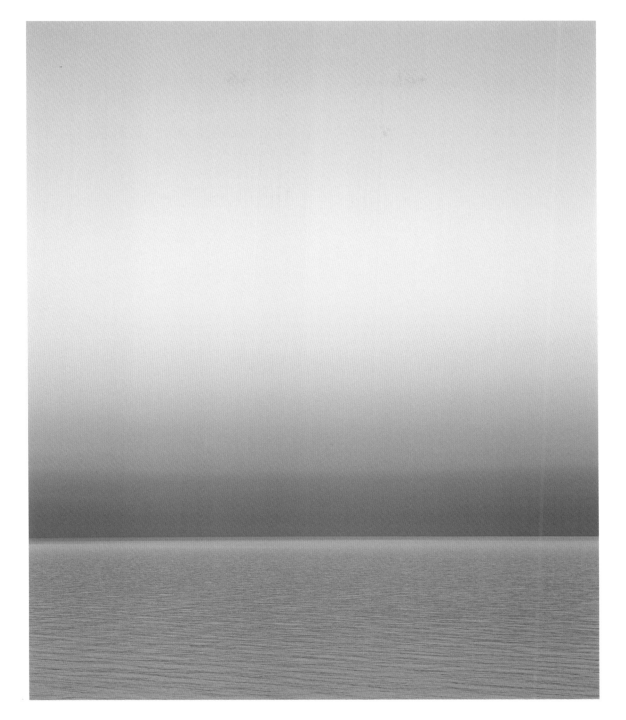

X — 2

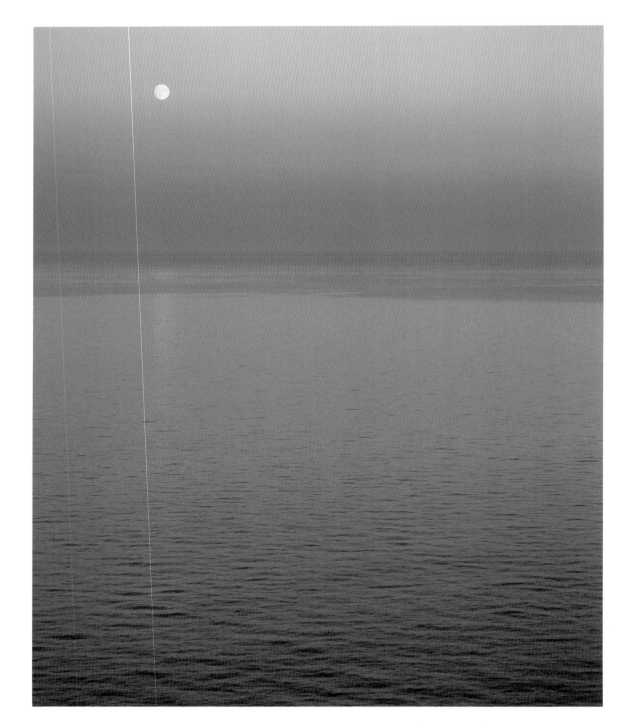

X — 3

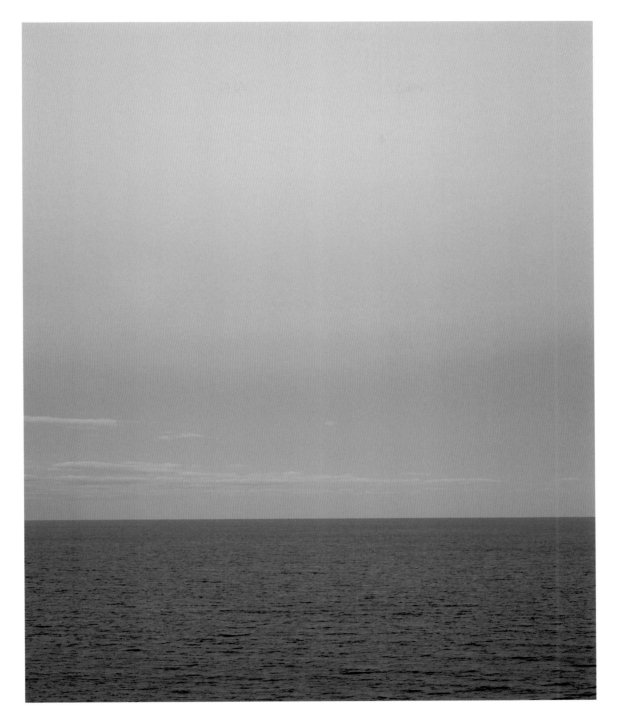

X — 4

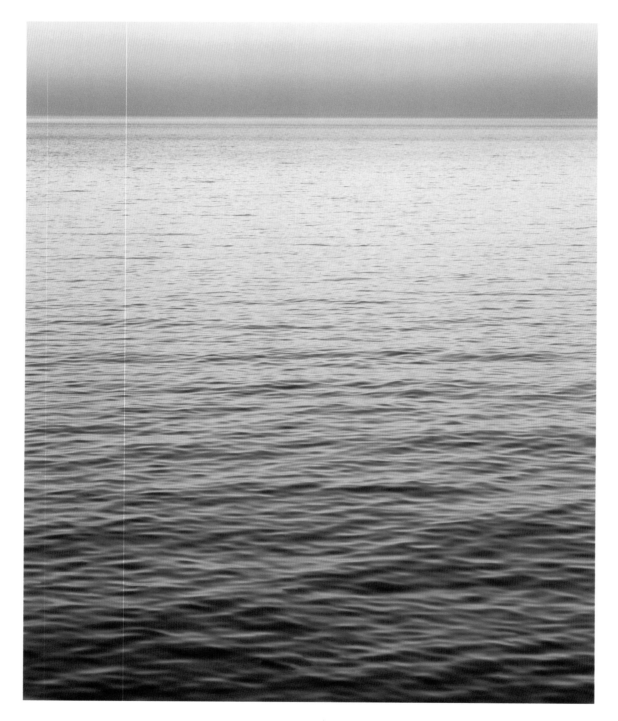

X — 5

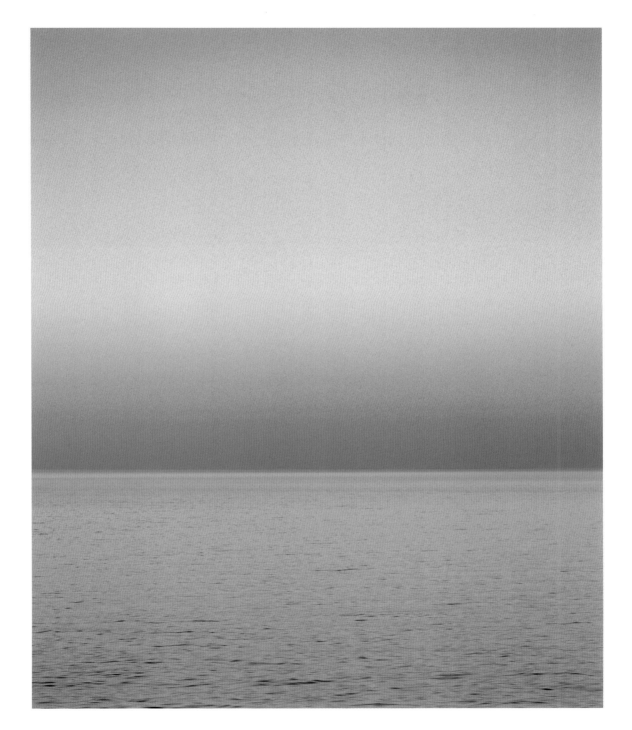

X — 6

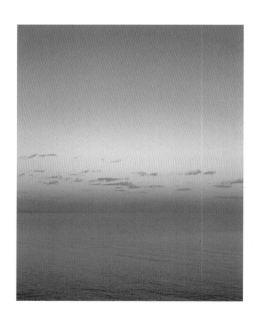
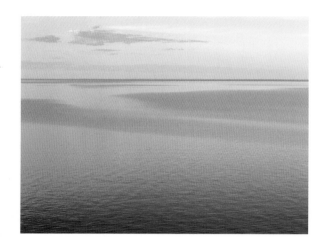
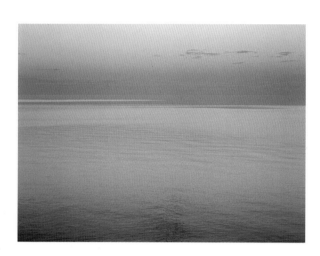

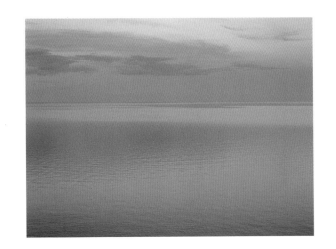
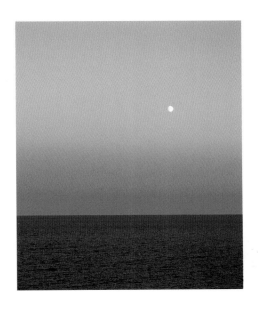
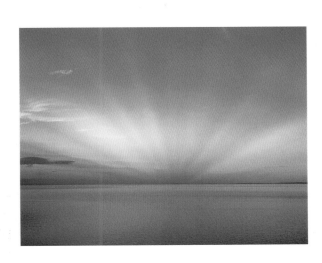

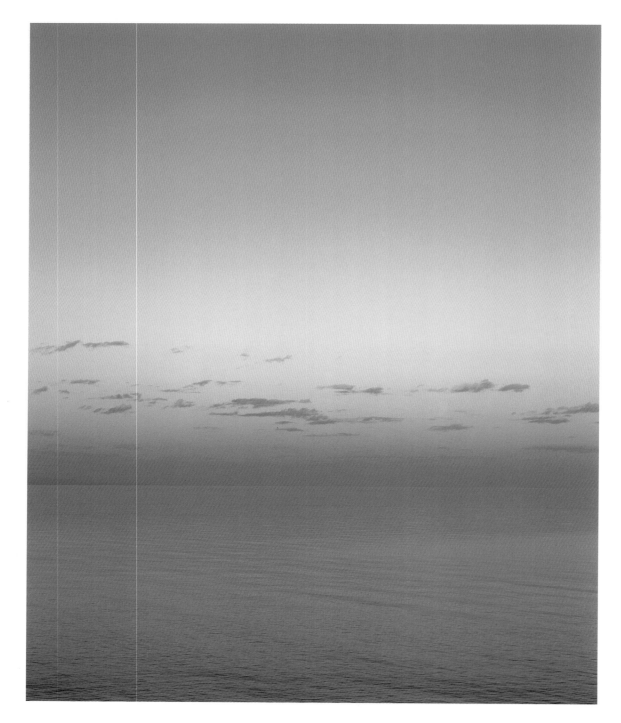

XI — 1

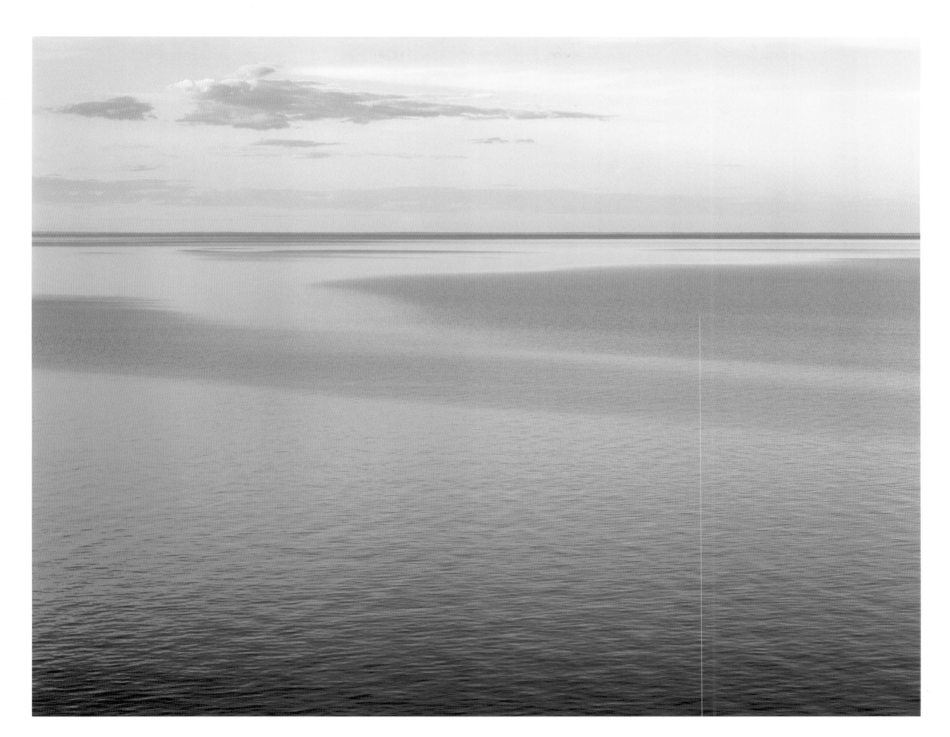

XI — 2

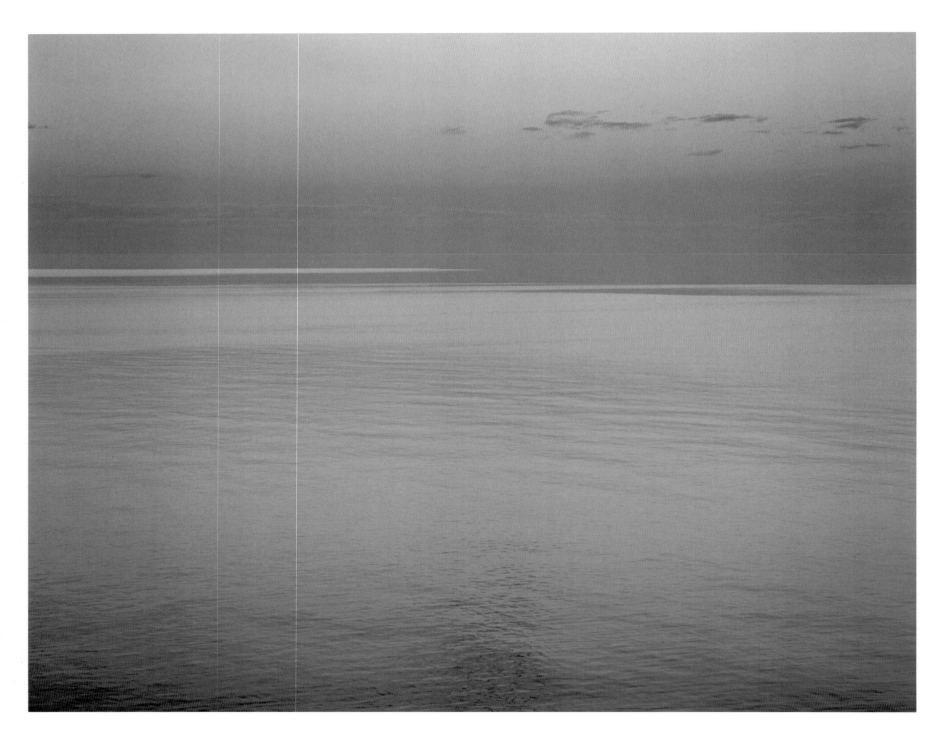

XI — 3

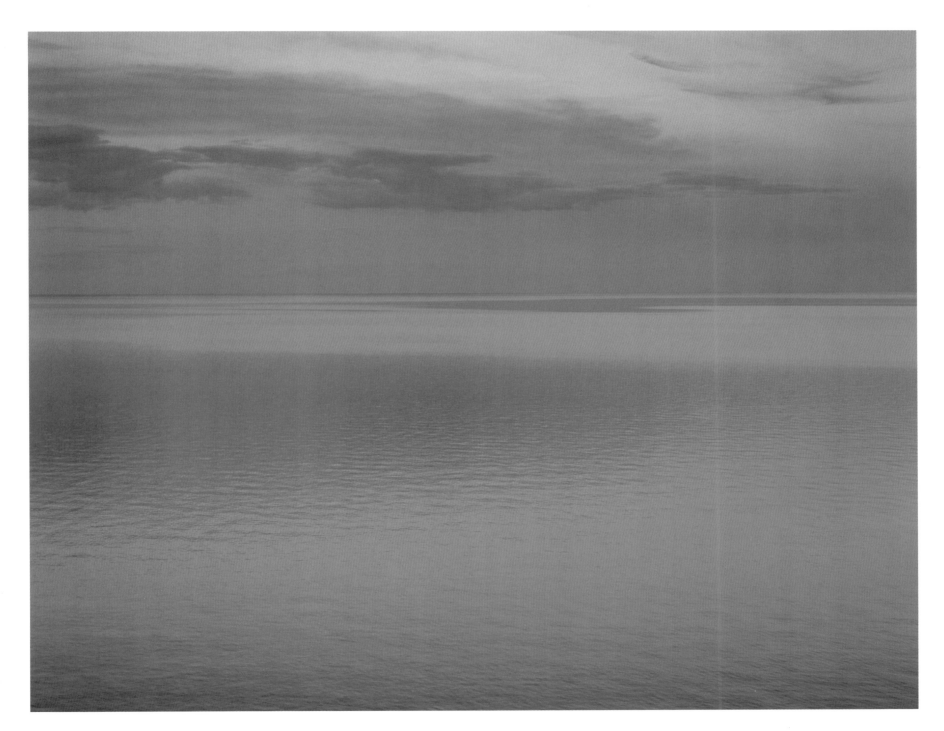

XI — 4

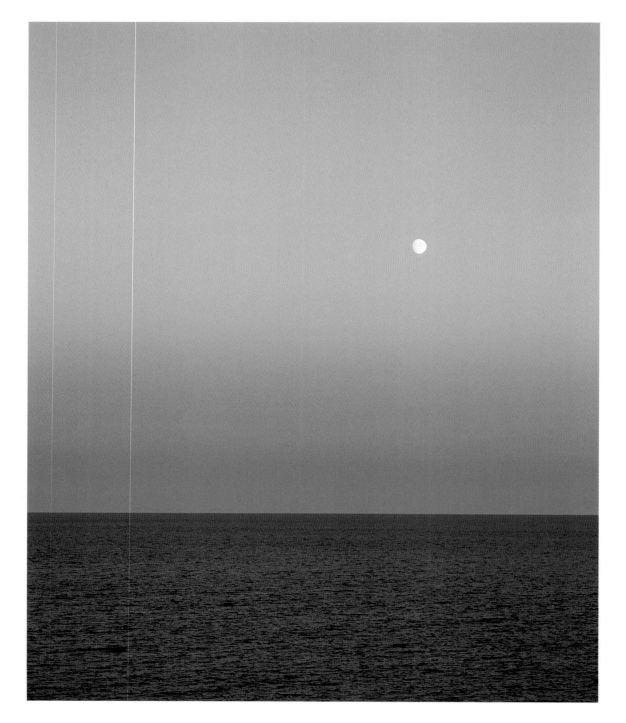

XI — 5

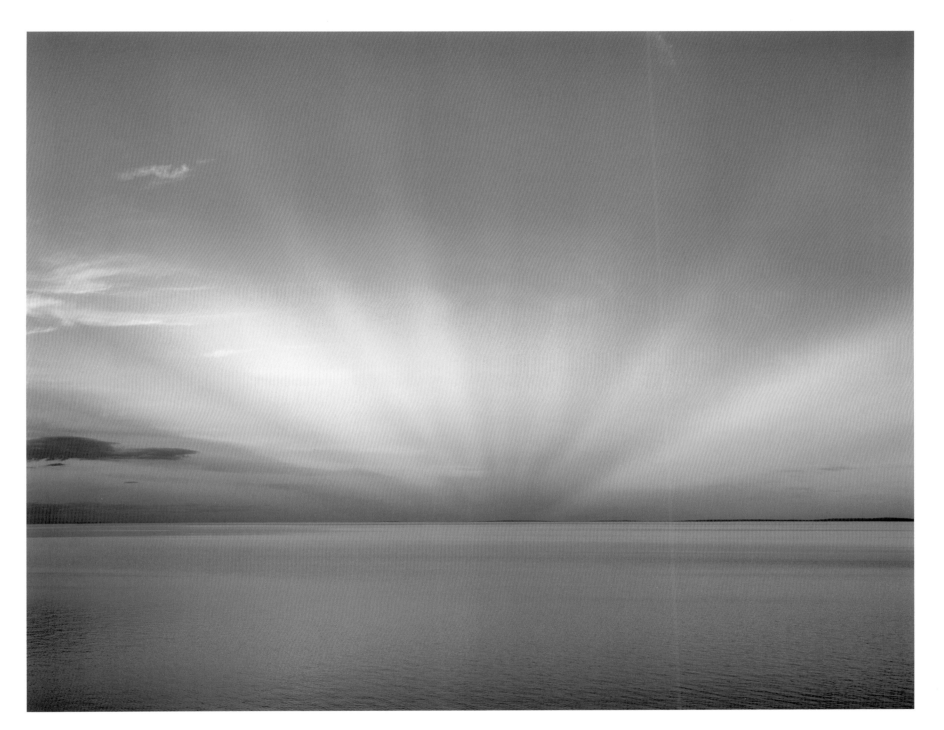

XI — 6

All photographs in this book are available in a limited edition of ten, 22x28 inch, and ten, 34x42 inch prints from:

BLACKLOCK
PHOTOGRAPHY
GALLERIES

Moose Lake and within Waters of Superior stores in Duluth and Grand Marais, Minnesota.
218-485-0478 www.blacklockgallery.com

BLACKLOCK • HORIZONS

Photographs and text, © 2002 by Craig Blacklock

Printed in Korea by Doosan Printing

ISBN 1-892472-11-2 First Edition 02 03 04 05 06 07 5 4 3 2 1

Blacklock, Craig 1954 —

Published by: Distributed by:
Blacklock Nature Photography Adventure Publications, Inc.
P.O. Box 570 820 Cleveland Street South
Moose Lake MN 55767 Cambridge MN 55008
218-485-8335 1-800-678-7006 & 1-877-725-0088